LUCAS SAMARAS

LUCAS SAMARAS: PHOTO-TRANSFORMATIONS

An exhibition organized by
The Art Galleries, California State University,
Long Beach
November 17-December 14, 1975

Essay by Arnold B. Glimcher
Edited by Constance W. Glenn

University of North Dakota Art Gallery
Grand Forks, North Dakota
February 17 - March 10, 1976
Wright State University Art Gallery, Dayton, Ohio
April 4 - April 25, 1976
Institute of Contemporary Art, Boston
May 7 - June 7, 1976
Modern Art Pavilion, Seattle Art Museum
June 18 - July 18, 1976
A.C.A. Gallery, Alberta College of Art
Calgary, Alberta, Canada
August 15 - September 15, 1976

California State University, Long Beach

and

E.P. Dutton & Co., Inc., New York

GALLERY STAFF:

Constance W. Glenn, Director
Jane Bledsoe, Jody Rassell, James Wilson, Steven Seligman.

Printed by Typecraft, Inc., Pasadena, California.
Black and white photographs courtesy of The Pace Gallery, New York, and the artist.

This exhibition is supported by a grant from the National Endowment for the Arts, Washington, D.C., a Federal agency; and by the Associated Students, School of Fine Arts, Department of Art, California State University, Long Beach.

ACKNOWLEDGEMENTS

Although it is not possible to separately list the many contributors to this exhibition, I am particularly grateful to Arnold Glimcher of the Pace Gallery for his most articulate essay on the art of Lucas Samaras; to Judith Harney of the Pace Gallery for her continued cheerful and efficient assistance; to the lenders who provided sculpture by the artist for the Long Beach portion of the exhibition: Mr. and Mrs. Michael Blankfort, Mr. Robert Halff and Mr. Carl W. Johnson, Mr. Sterling Holloway, Mr. Jack Glenn, Mr. and Mrs. Robert A. Rowan, and the San Francisco Museum of Art, Gift of Sally Lilienthal; to David Anderson of Typecraft, Inc.; to the National Endowment for the Arts for its support of the exhibition; and finally to Lucas Samaras, who made the exhibition possible.

The California State University Long Beach Foundation and The Art Galleries especially wish to thank Robert H. Halff for his support of the exhibition.

Constance W. Glenn

PREFACE

For the first time in its short history, photography as an art form is attracting a large audience which includes not only the artists, critics, collectors and historians, but a significant segment of the public as well. In the examination which inevitably follows such an explosion of interest in a particular art, it is natural to look to the work of an artist who has not only made an acknowledged, if unconventional, contribution but who has throughout a career distinguished by production in many media consistently used the medium of photography to achieve his own most personal ends.

Lucas Samaras' involvement with photography can be traced to the early use of self-portraits (taken by others) in his BOXES, and to date has culminated in the AUTOPOLAROIDS begun in 1969,[1] and in the PHOTO-TRANSFORMATIONS which have occupied him since 1973.

The mystique and misunderstanding surrounding the use of technical or mechanical means to an artistic end have not played a part in Samaras' career as a photographer.

Perhaps because his photographs have sprung from a larger body of work in painting and sculpture, and perhaps because his manipulation of the photographs transforms and personalizes them. They are unique.

The AUTOPOLAROIDS and PHOTO-TRANSFORMATIONS can be viewed as containers for his imagery, thus they become objects, operating not only on the level of highly sophisticated photography, but on the level of his sculpture — image crammed BOXES — as well.

Samaras has been called a magician, but his magic is in his art, rather than in the technological innovations he has developed in conjunction with his use of the Polaroid 360 camera, and since 1973 the revolutionary SX-70. He is not loath to discuss his technical "trickery," convinced that the nature of his art is philosophical, and abetted but not in any way created by the technical/mechanical means at his command. For a better understanding of both photo and process, it is possible to examine PHOTO-TRANSFORMATION 7/4/75 on the front cover of this

catalogue. It does not appear in the exhibition and all of the exhibition works precede it— thus in a sense allowing it to be; however, because there is explicit technical information available regarding it, it partially illuminates the earlier works.[2] The central image is manipulated or pushed around with the same sort of gesture one might expect of the artist with a brush. The rainbow hues, which seem significantly softened in this newest work, are Samaras' own in all of his art, whether seen in jewels and swirls of colored yarn, or created by the use of electronic strobe flash units covered by red mylar, green mylar, and a piece of broken blue glass.[3] The two images of the body or two self-portraits appear throughout Samaras' use of photography. Even prior to the making of his photographs, dual images were not uncommon.[4] In the AUTOPOLAROIDS the double or multiple images were created by "fooling" the electric eye of the camera, thus allowing approximately twenty seconds to manipulate the possible number of exposures. Two portraits of the artist appear in the cover transformation, and because of past information, we again presume a double-exposure; however, in truth, Samaras has now left the picture entirely save for his floating remainder in the form of a snake "S." The artist at the left, seated in a chair, before a tripod with a Polaroid 360 camera mounted on top (blurred just enough to appear to be two and full of **double entendre** regarding the artist's

studio/studio photographer) is in reality a life-size metal cutout placed close to a blank wall and casting a small shadow due to high intensity lighting.[5] The second (and true) portrait, a tiny but perfectly focused face of the artist, is accompanied by the bizarre floating or detached body — the illusion of floating created by Samaras jumping before the lens and the "S" snake created by the extension or manipulation of the photo-emulsion which we have become accustomed to in the PHOTO-TRANSFORMATIONS exhibited here. In this particular photograph the violence, eroticism and horror are subjugated to the examination of multiple sources of body imagery — always self-referential — and greater concentration on evocative, if miniaturized, details and symbols (the enigmatic television image and iconic candle).

Whether considering this newest transformation or those which comprise the exhibition, one might note that as photographs are being hung alongside drawings and paintings in the museums, Samaras is being hailed, on the basis of these works, as artist/photographer. Prudence would remind us that, as he has hop-scotched the traditional, potential and untried art media, he has made each his own. We need not expect to see him in this guise again. As always his art is proffered as "a complicated gift."[6] CONSTANCE W. GLENN

NOTES:

Unless otherwise stated, all information was drawn from conversations with the artist during June, July and August 1975.

1. At the time of the publication of the SAMARAS ALBUM in 1971, they were referred to as AUTOPHOTOGRAPHS.
2. PHOTO-TRANSFORMATION 7/4/75 is part of a new series begun in July of 1975, following a one year period during which no photographs were made. During a single shooting session the artist may make a number of versions of one image, or on occasion devote the whole session to the exploration of one particular situation or concept. The new images from July 1975 will be exhibited at the Pace Gallery in October-November 1975.
3. Samaras found the blue in a particular glass provided the color he desired, broke the glass, and used the piece for the needed filter.
4. See UNTITLED "Face-Box" (Levin, Plate 108); BOX#8 (Levin, Plate 110); BOX #10 (Levin, Plate 113); and Double Nude Photograph with LARGE TINFOIL FINGERS (Levin, Plate 142).
5. The metal cutout sculptures will also be included in the Pace Gallery exhibition.
6. Samaras, Lucas. LUCAS SAMARAS. The Whitney Museum of American Art. New York, 1972.

LUCAS SAMARAS: PHOTO-TRANSFORMATIONS

Samaras' art is essentially one of auto-portraiture, obsessed with the formation of self-images in terms of visual metaphors. Although the body of exclusively photographic work is relatively recent within the corpus of Samaras' art, beginning in 1969 with the film SELF, his interest and study of the medium began with a high school elective photography class and continued in college.

The photographic image as a pre-made component appears as a dominant element in the boxes of the 60's. In BOX #8 (figure 1), the interior surface is covered in a series of self-portraits developed as line, dropping out all half-tones and further transformed by a surface of pins, yarn, and string. Often pornographic photos are used and sometimes grotesque medical abnormalities are made more repulsively unthinkable by juxtaposition with gleaming jeweled and natural treasures, like sea shells and painted marbleized grasshoppers. Previously, pornographic photos were used as a starting point in the production of pastels in 1960. Most often the photo images are portraits of Samaras peering out from a tear inside the nail-lined lid of a box (BOX #38, figure 2), or hidden in glass vials like time capsules stored for future discovery. Continually repeating themselves, these images are rejuvenated by new materials and contexts. In a 1968 photograph, Samaras holds his gigantic lens-reflected face in his hand (figure 3). In PHOTO-TRANSFORMATION, 11/12/73 (figure 4), a distorted snarling creature holds his miniature, sharp focus image in a shaving mirror and in 1974, hidden in the vault of a reliquary, Samaras again distorts his image, this time under a conical lens set for consumption on a chiffon cloth between a fork and a spoon (figure 5). In a black and white photograph taken in 1966, we view the artist from behind a door baptizing himself with a shower of water (figure 6) and in PHOTO-TRANSFORMATION, 9/19/73 (figure 7), from behind a panel of rainbow lollipop color, Samaras bathes in a shower of light.

Samaras rapaciously devours different media within which he extends his visual vocabulary. Realizing the results, specific to certain media, he capitalizes

upon the possibilities inherent in carving stone or wood (figure 8), modeling with clay, or rags dipped in plaster (figure 9) and assembling selected and altered objects (figure 10). Within the AUTO-POLAROIDS, Samaras explored the possibilities of painting with colored lights. In the PHOTO-TRANSFORMATION series, he extends these accomplishments to illuminate the acting techniques developed at Stella Adler's, and saved since his performances in the Happenings of the early 60's. These tableaux are extended mirror muggings like the reality testing devices of children, who in an attempt to overcome fear, assume the facial grotesques of imagined monsters, only to scare themselves by the seduction of their own portrayal. In the photo images, Samaras survives his pantomime self-destruction. He is the perpetrator of unspeakable social crimes, exemplified in his film SELF, where he consumes photographic images (figure 11) of his sister, mother and father, illuminating his preoccupation with the fine edge between threat and seduction.

The arrested moment is exaggerated in the AUTO-POLAROIDS and the PHOTO-TRANSFORMATIONS by means of untrue color reminiscent of the cartoon world where steamrolled characters spring back to life again, denying mortality. Posing, he assumes all of the traditional roles within the art experience. He is both artist and model, a role historically enacted by wife and mistress, as well as self. These performances allow Samaras to rediscover his history in aesthetic as well as genetic terms. They also serve to graft him to the chronological continuation of history. The temptation to read art historical parallels into Samaras' imagery is largely the result of the technical exploration of all the options for human image formation, within the boundaries of associative credibility. But, as such, it cannot be denied that his outrageous depictions compete with his aesthetic and genealogical ancestors. In the series of images that appear as an homage to Van Gogh (figure 12), Samaras reverses the bandaged ear image by creating a fog bandage for the entire head and highlighting the ear, nose, eyes or mouth, in unnatural color. Screaming mouths radiating with linear and speckled patterns of light, recall not only the Eisenstein source of Bacon's imagery, but Charlton

Heston's fury as Moses descending the mountain in Cecil B. de Mille's TEN COMMANDMENTS. The torsos and backs lavishly painted with light are less a tribute to Matisse than the result of marzipan color stored from Disney cartoons, which were early film images seen by the presumptive artist in Greece before his post-war displacement in America. As in the films of Disney, Samaras largely up-lights his pictures, making the ordinary look sinister by reversing the expected order of shadow and highlights. Often his images are photographed from below, magnifying the image like the sorcerer's apprentice's broom, containing in it limited light reminiscent of the under-the-cover flashlight illumination of youthful night secrets.

Samaras' portraiture is also aligned with his Greek ancestry, where the precedent for nudity in Western art, is directly traceable. In 1966, Samaras began recording nude studies of himself on film, but at that point they were taken by another person. However, Samaras revealed to me that it was not until 1969 with the realization of the AUTO-POLAROIDS that he found the state or development of his body acceptable enough to keep. This decision to keep or save the photo-image of his body at a satisfactory stage of development is still another attempt to keep himself from decay, as are his alter images in the CHICKEN WIRE BOXES of 1972. The opulent flecks of color that envelop the CHICKEN WIRE BOXES cling like aphids to the skeleton of a leaf long after having devoured the flesh. This moribund lace describes the process of attrition rather than construction. Having already explored the skeleton and his future in the skeletal photo and pin constructions of 1965 and the colored pencil drawings of 1966, the PHOTO-TRANSFORMATIONS connect Samaras with his past in terms of satiric and tragic theater and Olympic meets. A sphinx with none of the elegance of antiquity, but rather the naked clumsiness of a new genus created by the rearrangement of its own familiar elements, is born out of the body of a Greek athlete (figure 13).

From the incense and pageantry of Greek orthodoxy, Samaras, the wizard, in league with extra-terrestrial power, summons the magic that belongs to the ancients. The miracle maker fulfills his promise of transformation that began at

Rutgers in 1958 (figure 14) and currently rests in the PHOTO-TRANSFORMA-TIONS (figure 15), that recall Henry Hull in the 1935 film THE WEREWOLF OF LONDON, in which Jack Pierce's extraordinary makeup allows a convincing transformation from man to wolf in front of the camera (figure 16). Yet, in other transformations, the shredded flesh of the mummy is remembered (figure 17) along with witches, sorcerers, satanic and divine invocations of creatures belonging to the history of magic.

Photographic excursions alone do not influence the images within the series. The pin BOXES of the early sixties have been extended into the image of a figure lifting the flayed sheet of skin from his torso to reveal the contents of steaming, spiky red flesh. His mouth, transformed into an incinerator consuming the fingers being fed from the edges of his lips (figure 18), recalls the yarn BOX #36 (figure 19) in which, under a photo-lined lid, cast acrylic fingers emerge from a jeweled quicksand field. Giant aluminum fingers recorded in photographs of his studio, circa 1966, are also recalled (figure 20).

To realize these feats, Samaras required a medium in which the lag between concept and output of expression was significantly diminished. He accomplished this with the Polaroid SX-70 camera. In previous works he dealt with this need by employing assemblage techniques, which facilitated the selection or recognition of existing images, without having to sculpt or paint them into existence. Selection itself became a sculptural act just as it now becomes a painterly act in the PHOTO-TRANSFORMATIONS. This desire for immediacy is not unique to Samaras; it is one of the major characteristics of twentieth century art that has led artists to solutions in new media. The desire to produce a work as immediate and fresh as its preconscious model, motivated Masson to produce automatic works as it did de Kooning to produce action paintings and as it currently directs the conceptual artists. Process itself becomes the tool for the recognition of visual concepts within the pigments by finding external matches for internal schemas. Thus, these transformations exist as a kind of improvisional theater of painterly expressionism.

The PHOTO-TRANSFORMATIONS are divided into two types: images in which the figure is transformed by the artist's physical contortion, extravagantly illuminated or painted with colored lights, and others in which his posed and lighted image is later distorted by manually altering the process of the film's development. As the image begins to appear, Samaras blends or mixes the photo-emulsion pigments using the surface as a palette in a kind of finger painting. The emergent forms and gestures are thus altered by the puppeteer who exaggerates attitudes by linear embellishments and fields of patterns. Even in instances of the most monstrous distortion, photo naturalistic clues to the image's original identity remain.

Unlike the contemporary body artist, the residual of whose performance is recorded on film, Samaras' picture is the total work as was his intention from the beginning. He denies his audience the sharing in the process that is the currency of the conceptualists, as well as the body artists. The picture mediates between Samaras and his audience. In Chris Burden's performances, he bleeds and the audiences see real blood in a one to one relationship. In the PHOTO-TRANSFOR-MATIONS, the deliberate removal from reality via distortion and scale, promotes the possibilities of multiple fantasy interpretations. In an age of immediacy where the **cinema verité** has been extended into the six o'clock T.V. news, Samaras deals with the depiction of personal terrors by perceiving and creating them as visual parallels. The anguish of a twisted fork, the threatening beauty of a vase of broken glass shards or the seduction of images behind veils of colored lights, all continue his scrutiny of combinations and possibilities for the transformation of his environment as an extension of himself.

Arnold B. Glimcher
June 1975

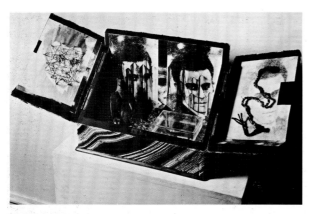

figure 1
BOX #8, 1963, mixed media, 11x15x8"

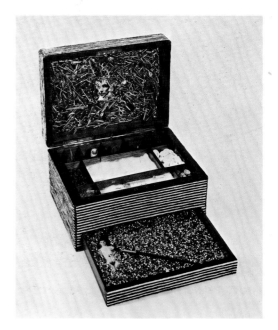

figure 2
Box #38, 1965, mixed media, 8x12x9"

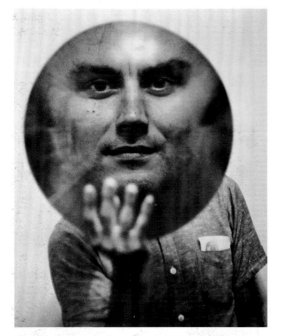

figure 3
Portrait of the artist 1968,
photograph by Dr. Henry Edelheit

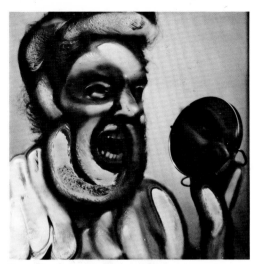

figure 4
PHOTO-TRANSFORMATION 11/12/73, 3x3″

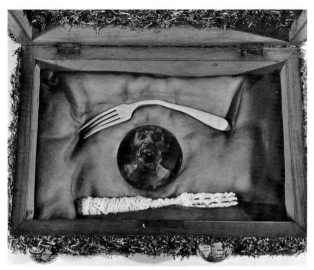

figure 5
From BOX #92, 1974, mixed media, 5½x14½x10½″

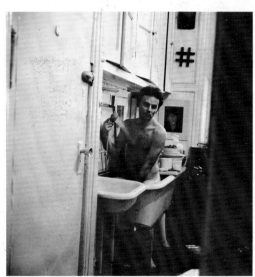

figure 6
Photograph taken in studio, 1966,
by Leo Mavrovitis

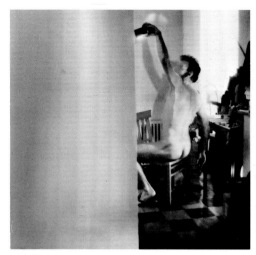

figure 7
PHOTO-TRANSFORMATION, 9/19/73, 3x3"

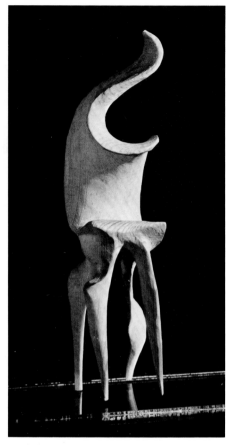

figure 8
From GROUP OF SMALL CHAIRS, 1970,
wood, $6\frac{1}{2}$x$1\frac{3}{4}$x$1\frac{3}{4}$"

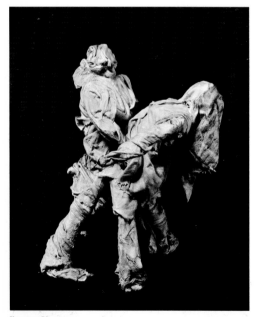

figure 9
UNTITLED (Rag Figures), 1959, cloth and
plaster, $9\frac{1}{4}$x$7\frac{1}{2}$x$7\frac{1}{2}$"

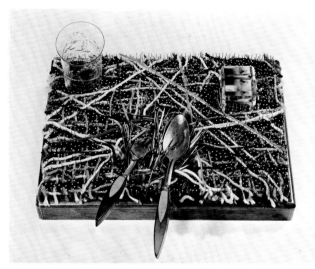

figure 10
DINNER #8, 1963, mixed media, 18½x8½"

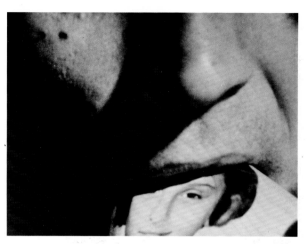

figure 11
Still from film SELF, 1969

figure 12
PHOTO-TRANSFORMATION, 10/31/73, 3x3"

15

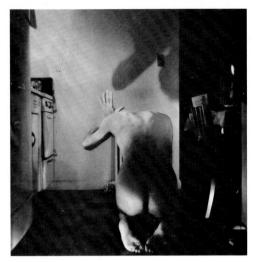

figure 13
PHOTO-TRANSFORMATION, 2/1/74, 3x3"

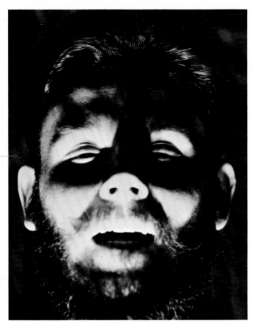

figure 14
Photograph taken at Rutgers University,
ca. 1958, by Keith Donaldson

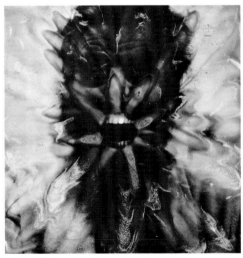

figure 15
PHOTO-TRANSFORMATION, 10/28/73, 3x3"

16

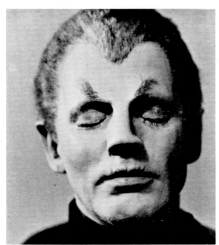 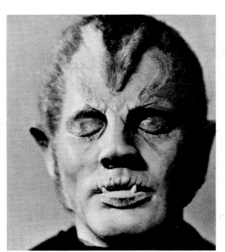 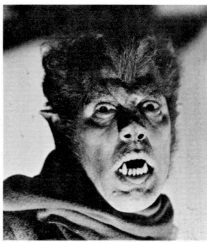

figure 16
Henry Hull in THE WEREWOLF
OF LONDON, 1935

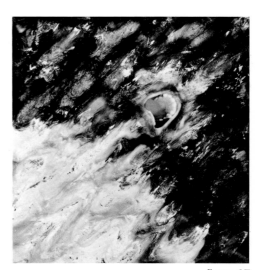

figure 17
PHOTO-TRANSFORMATION, 2/14/74, 3x3"

17

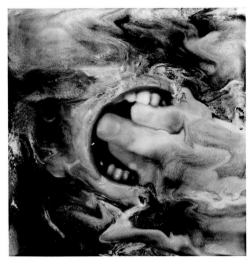

figure 18
PHOTO-TRANSFORMATION, 11/3/73, 3x3"

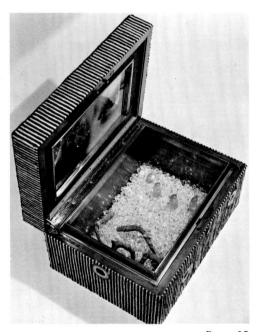

figure 19
BOX #36, 1965, mixed media, 6¾x13¼x9½"

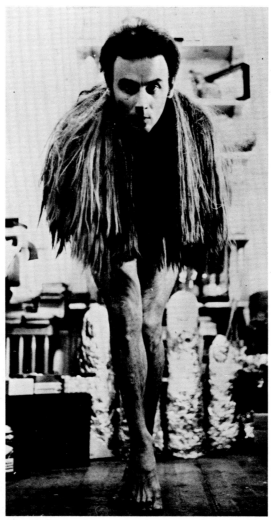

figure 20
Photograph in studio, 1966, by Leo Mavrovitis

May 29 '65

Went to visit Harry Shanis today and he suggested or asked if I had an idea to publish a box of drawings or something like it. Came home and thought about doing a complete photographic ~~job~~ of my body. A certain number of photos 20 - 30 showing detailed shots of parts. everything. the artists room, now the artists body. People before attempted this in limited way — Duchamp — Johns Whitman Morris. But this would be complete — anatomical — perhaps to be followed by another portfolio of body parts in unusual context = fork coming out of mouth, foot stepping on pins, hand strangling hand, foot by a sunset — prick by a sunrise — etc

figure 21
From the artist's diary, 1965

20

PLATES
Pages 22 through 61

COVER: PHOTO-TRANSFORMATION, 7/4/75

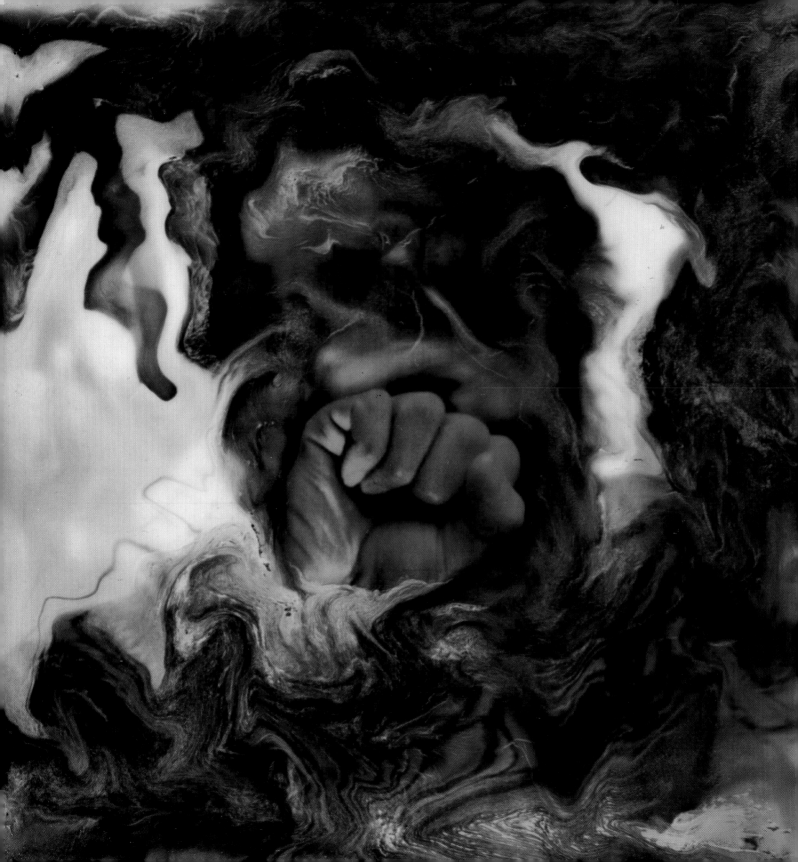

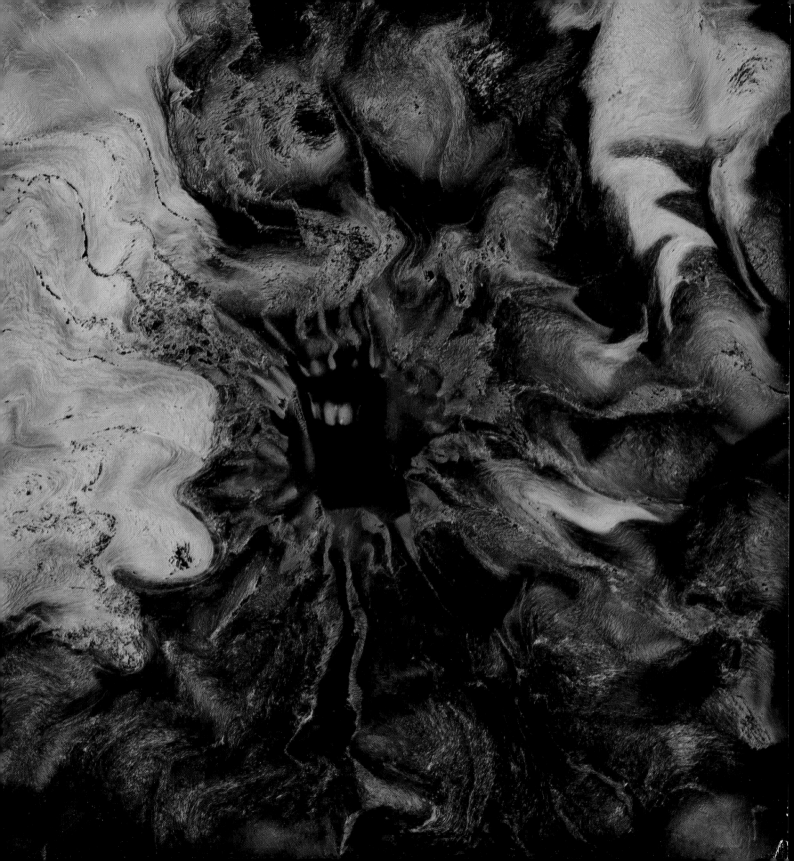

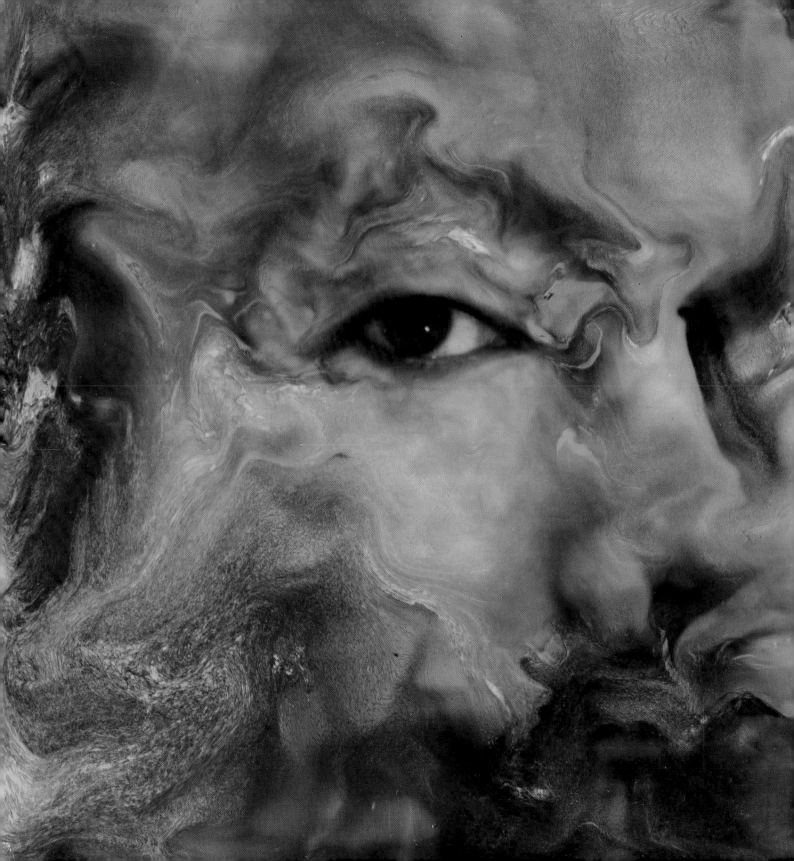

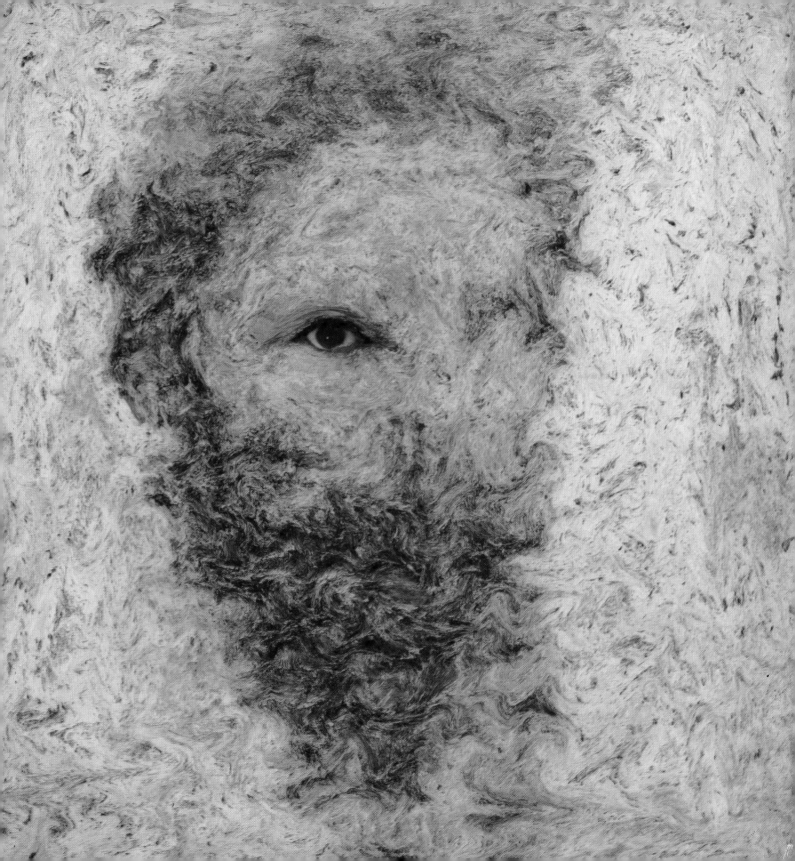

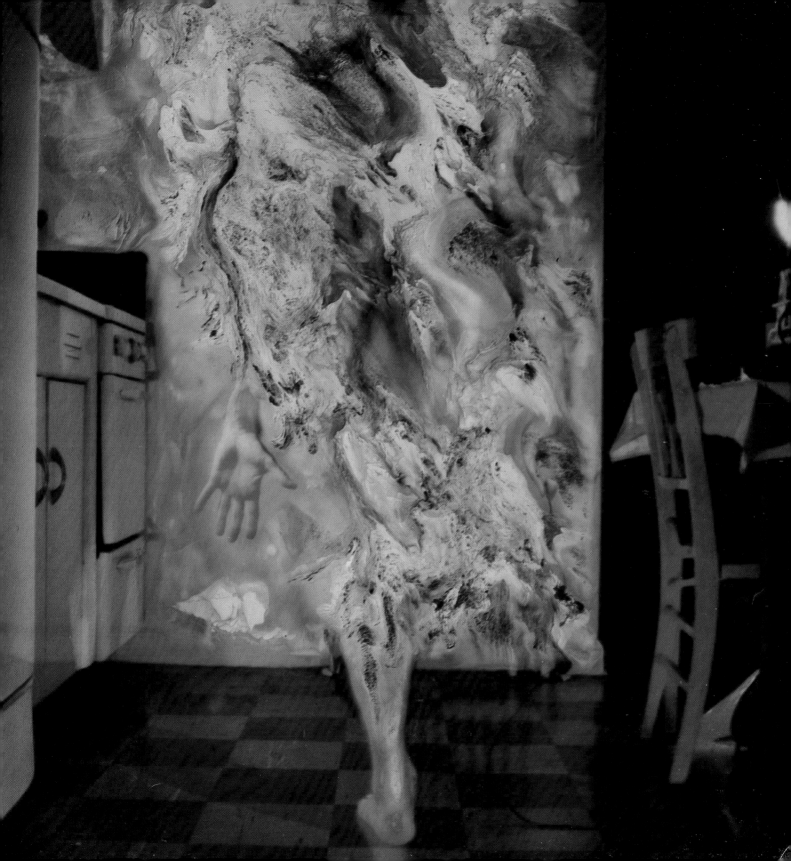

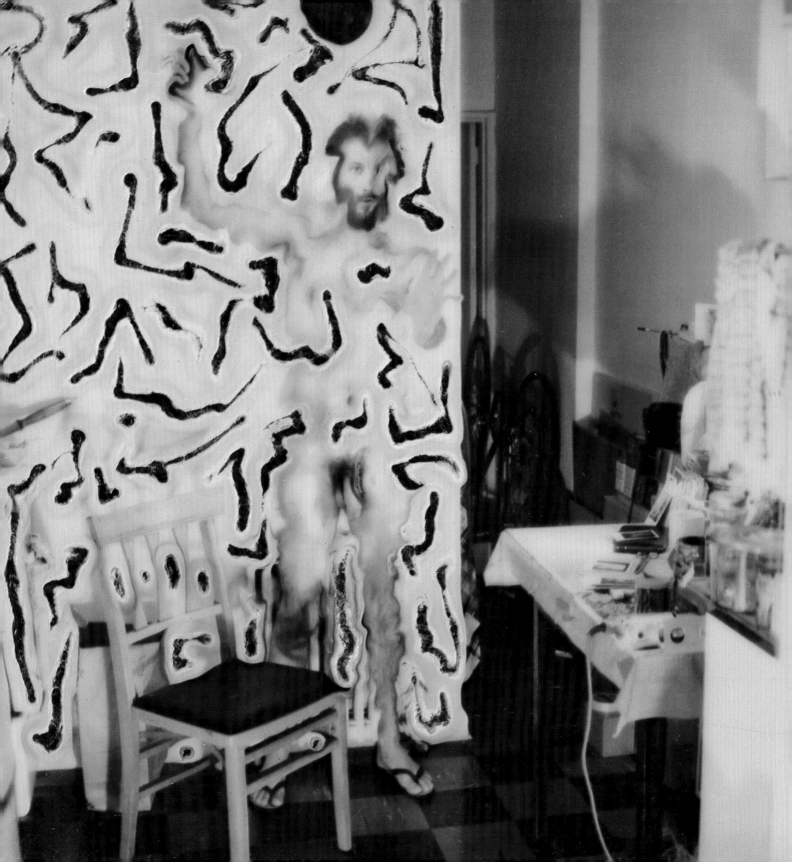

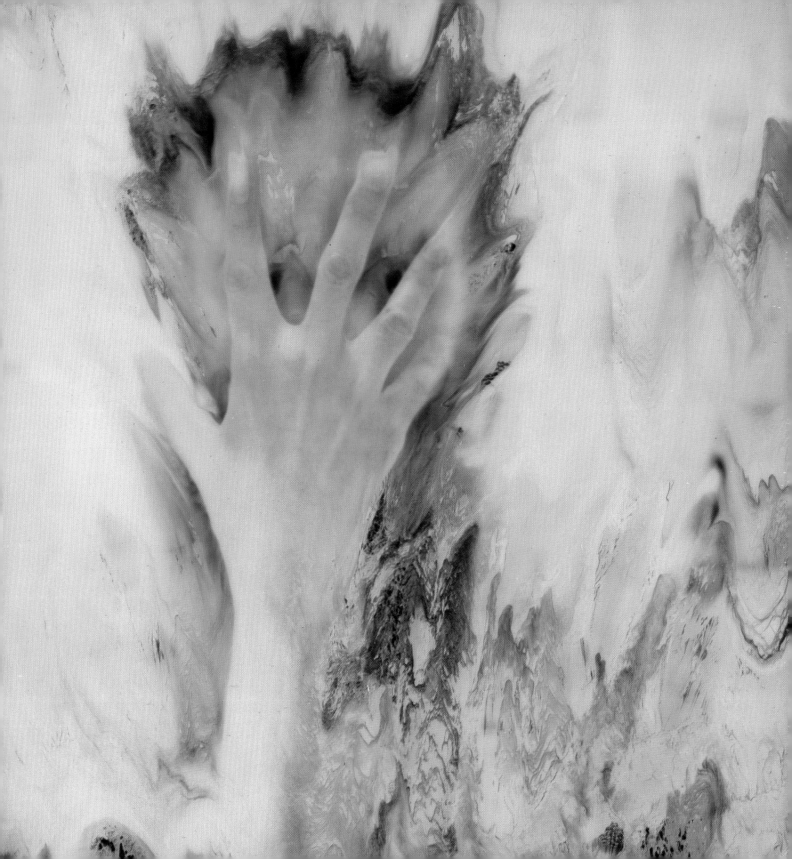

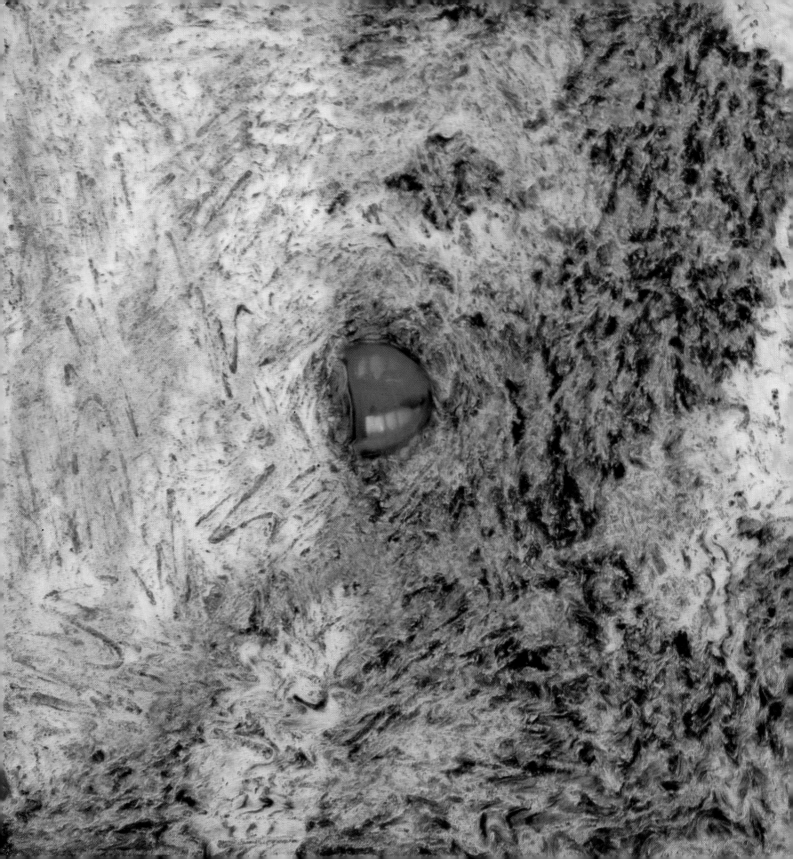

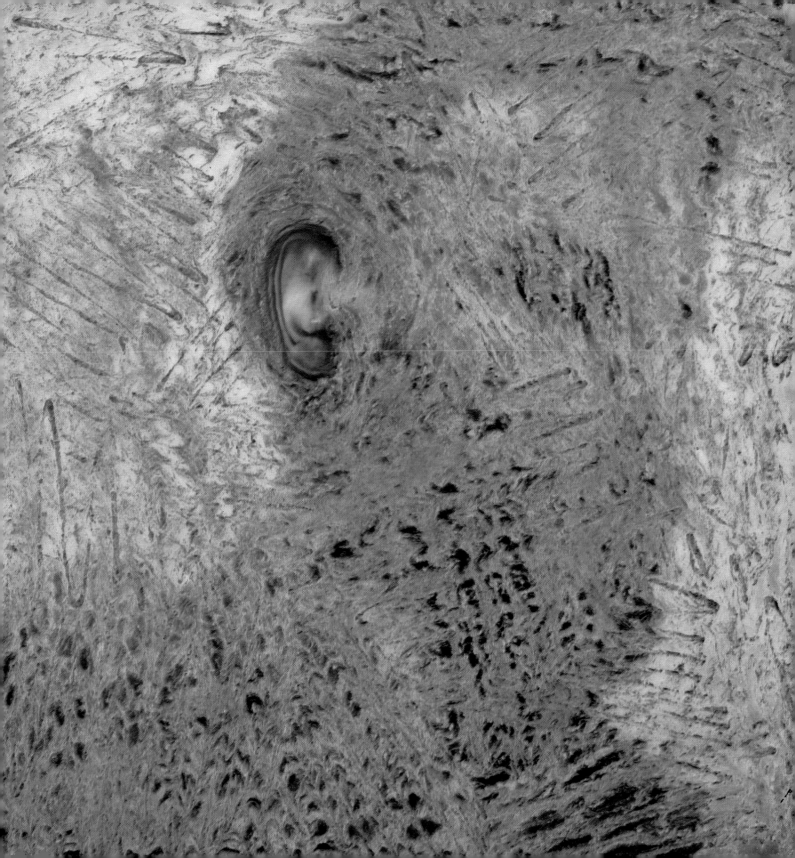

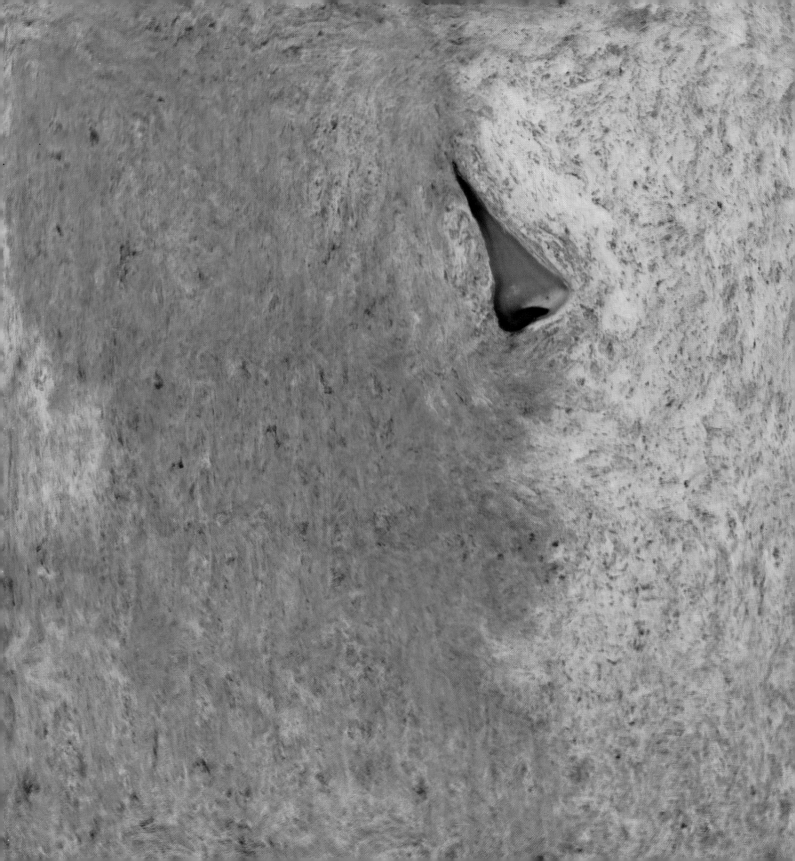

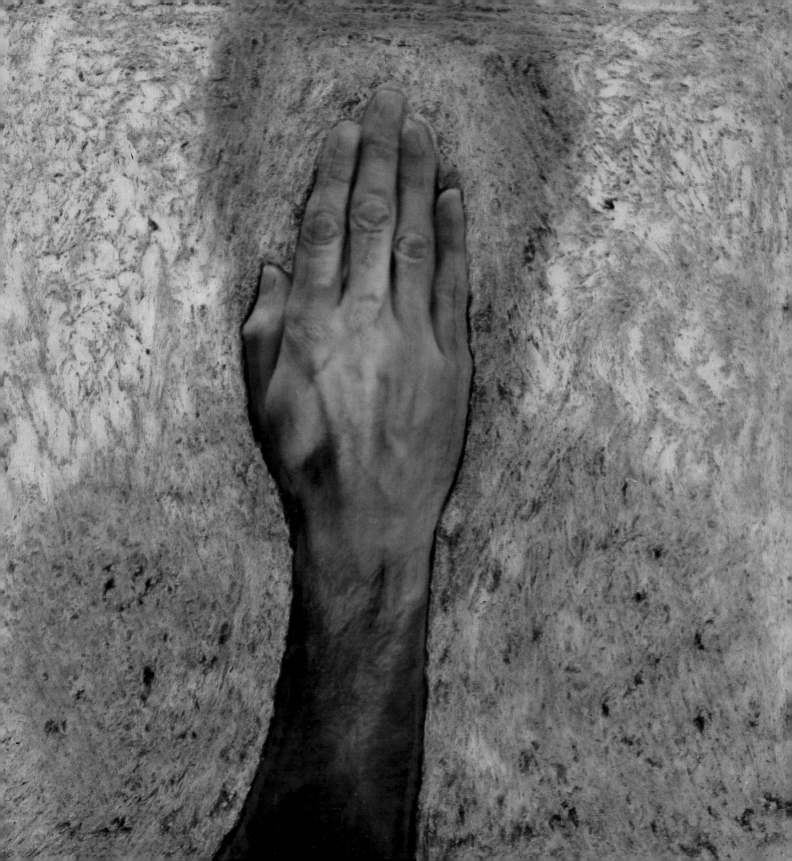

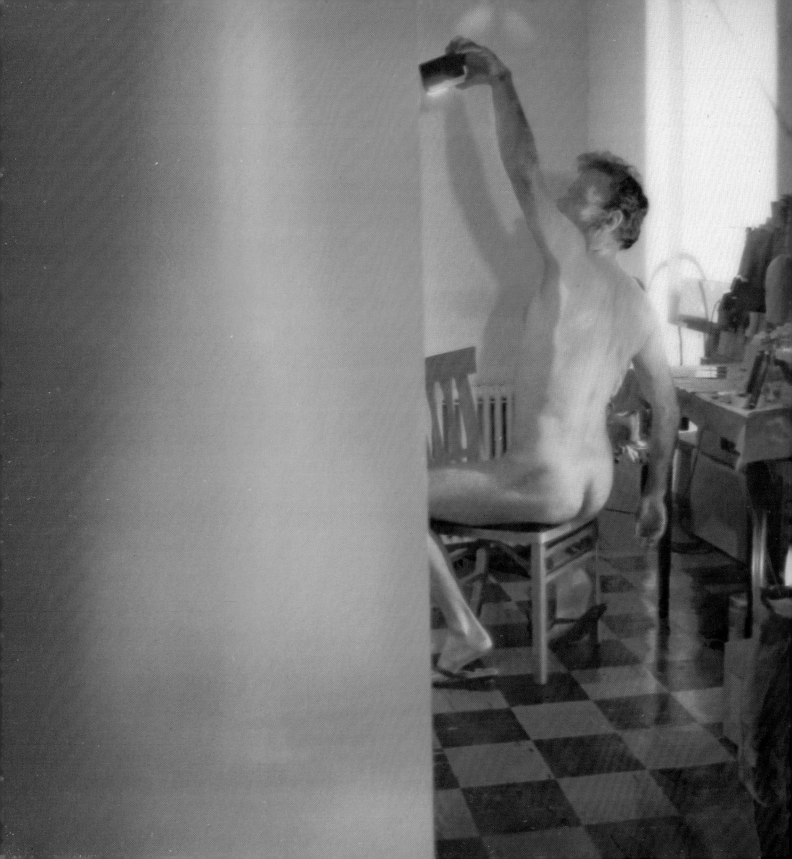

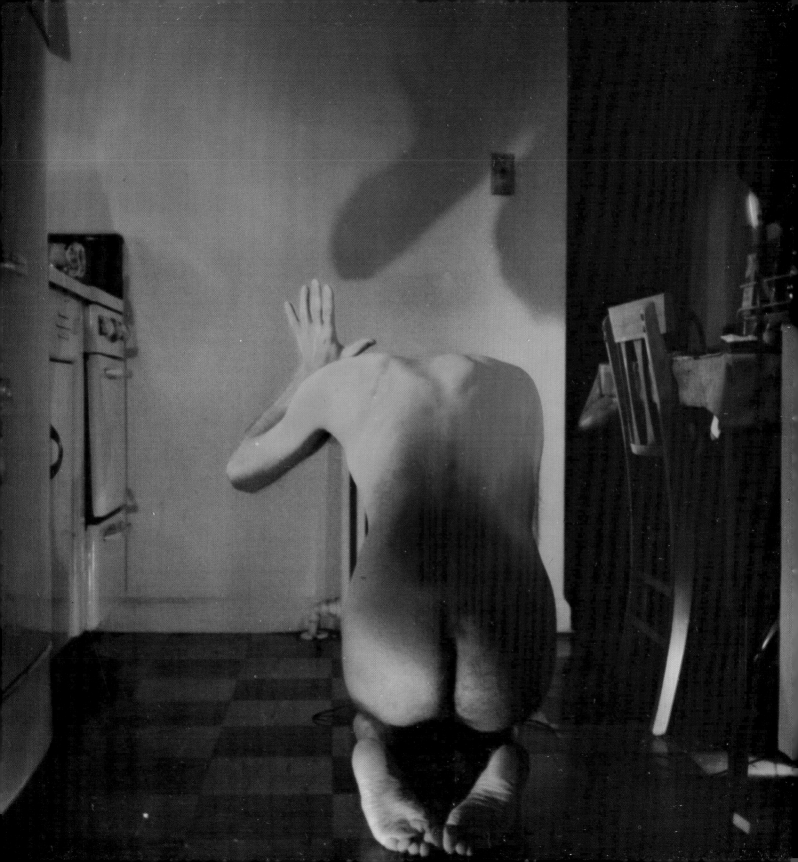

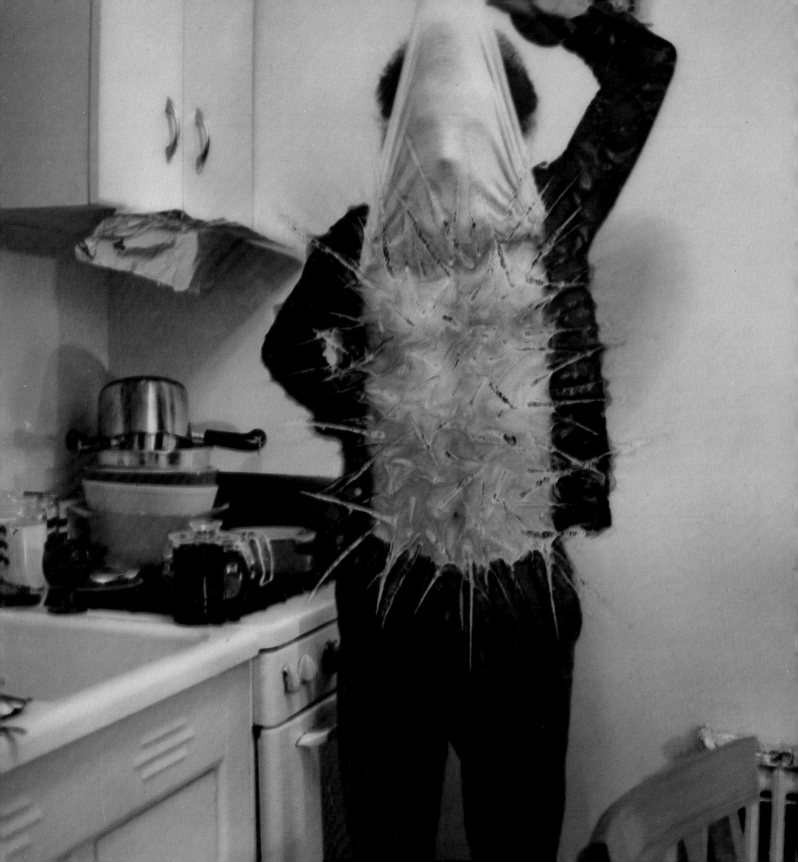

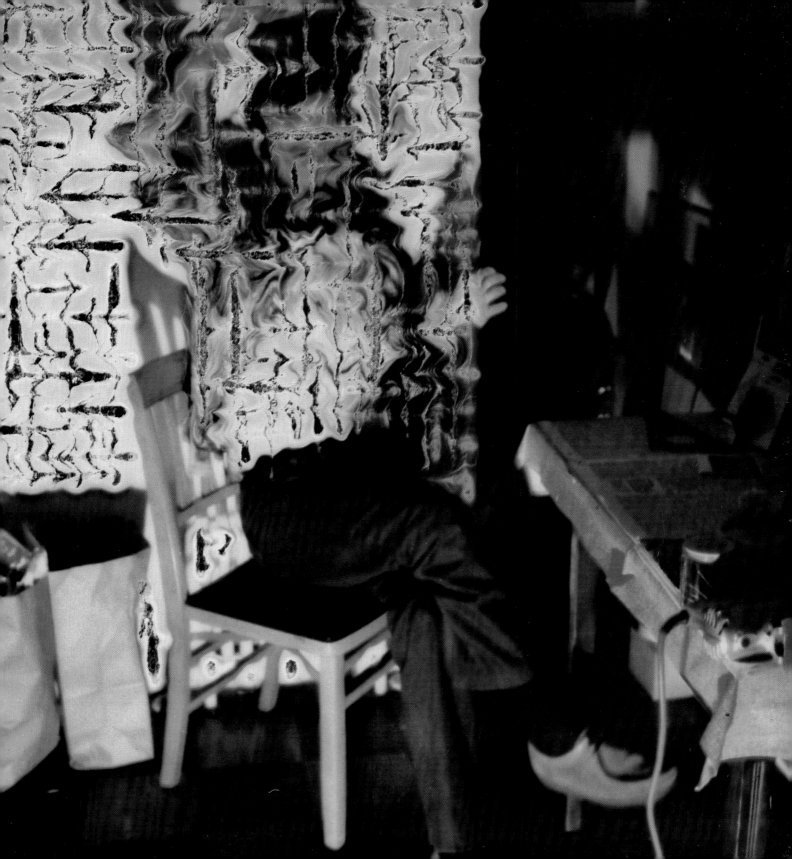

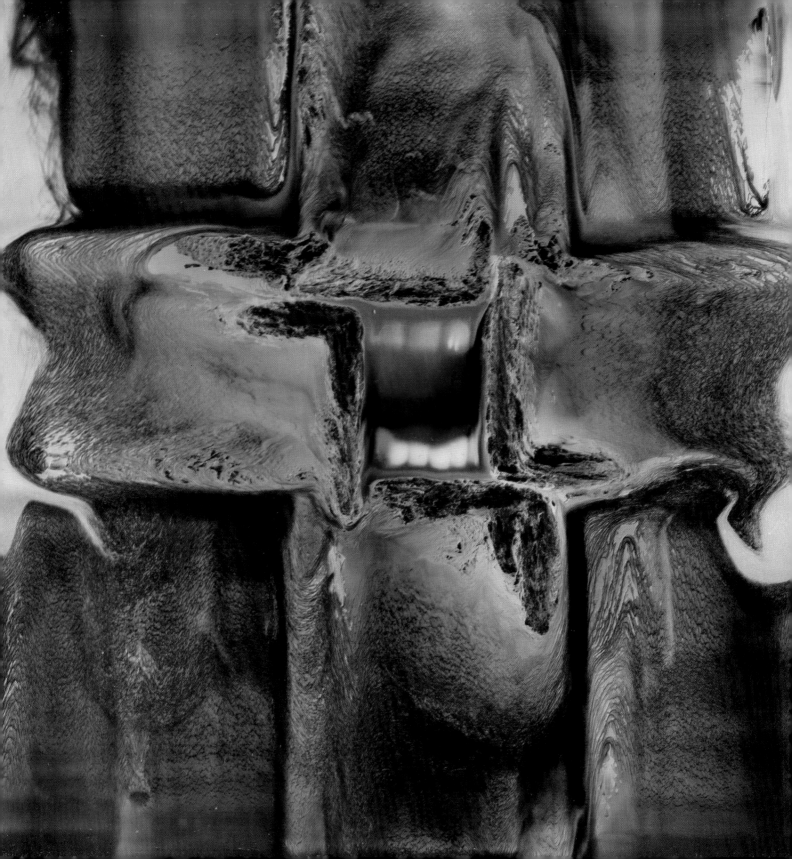

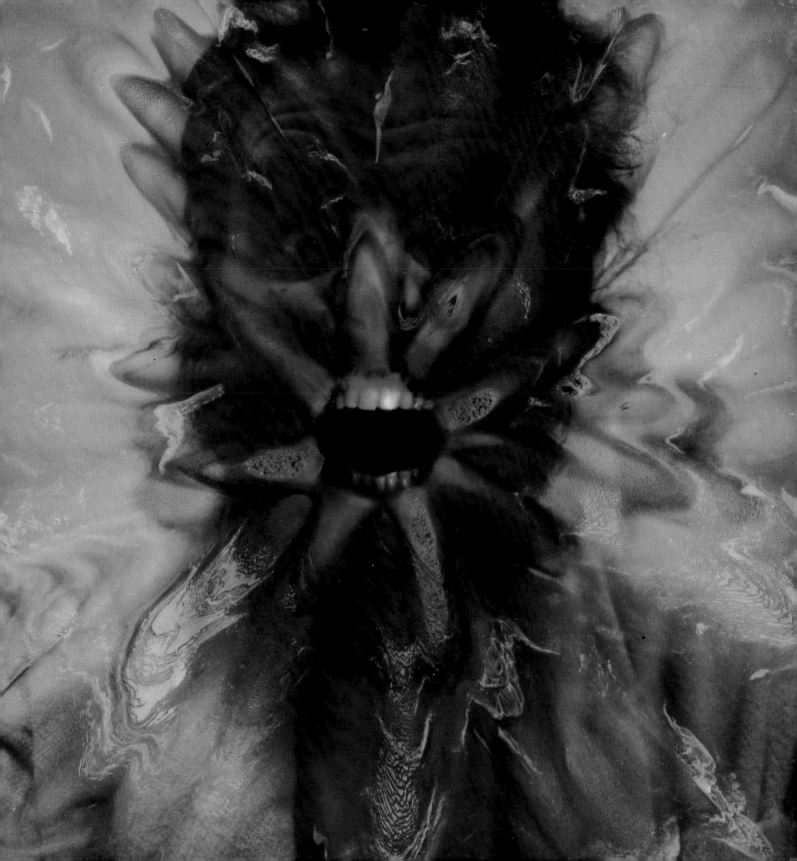

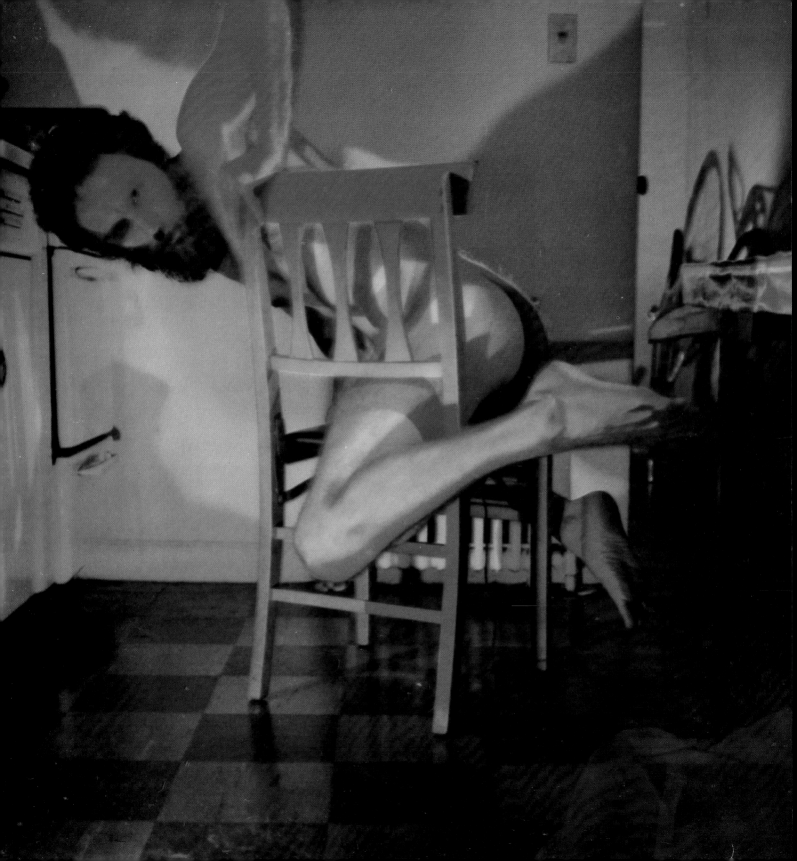

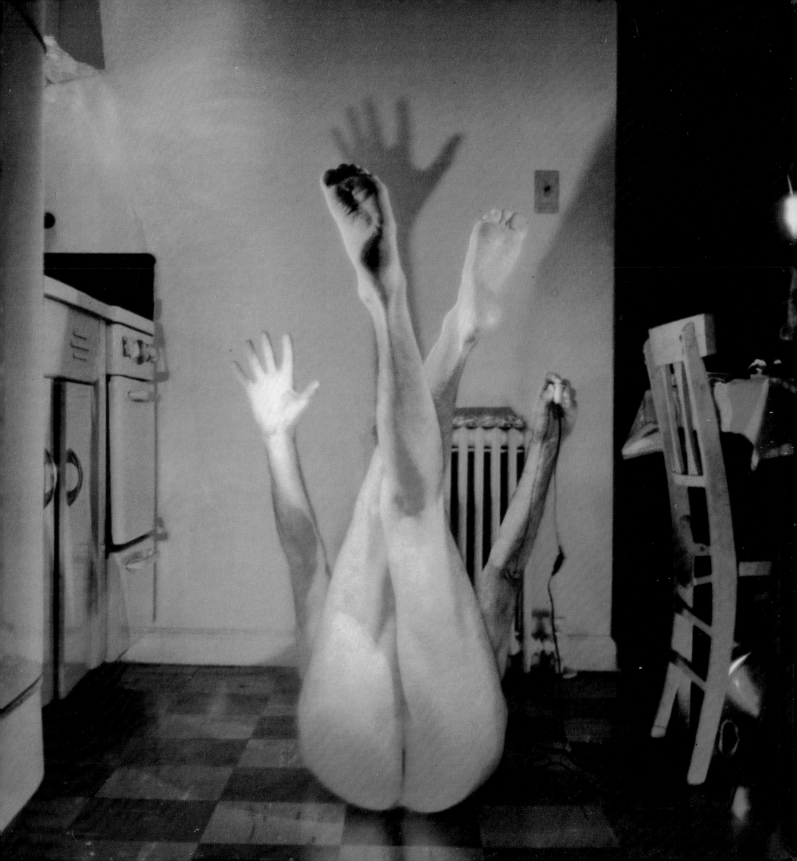

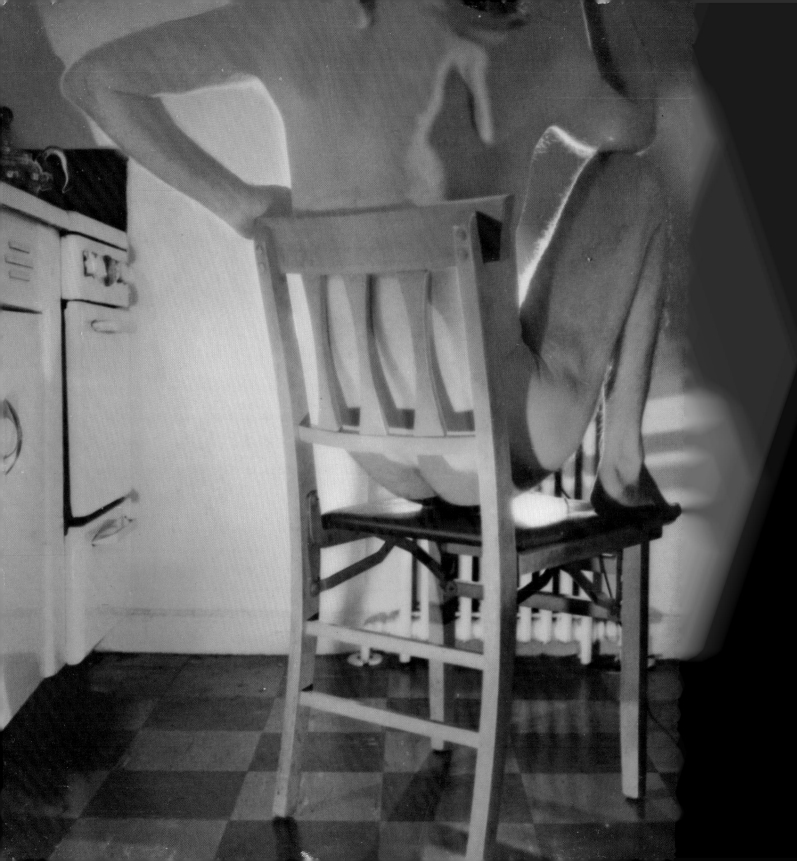

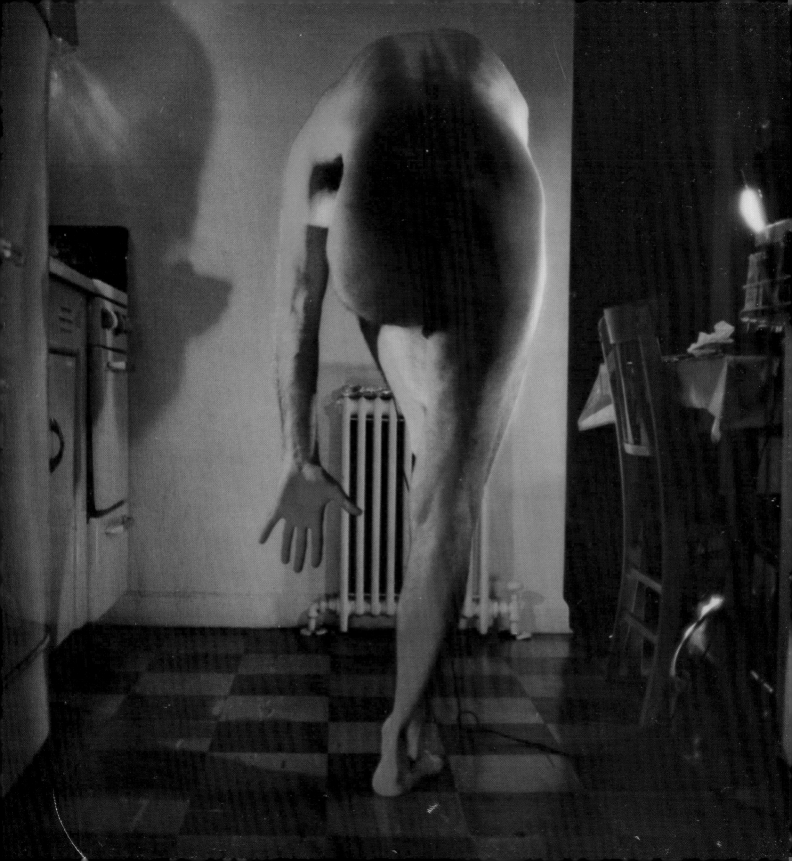

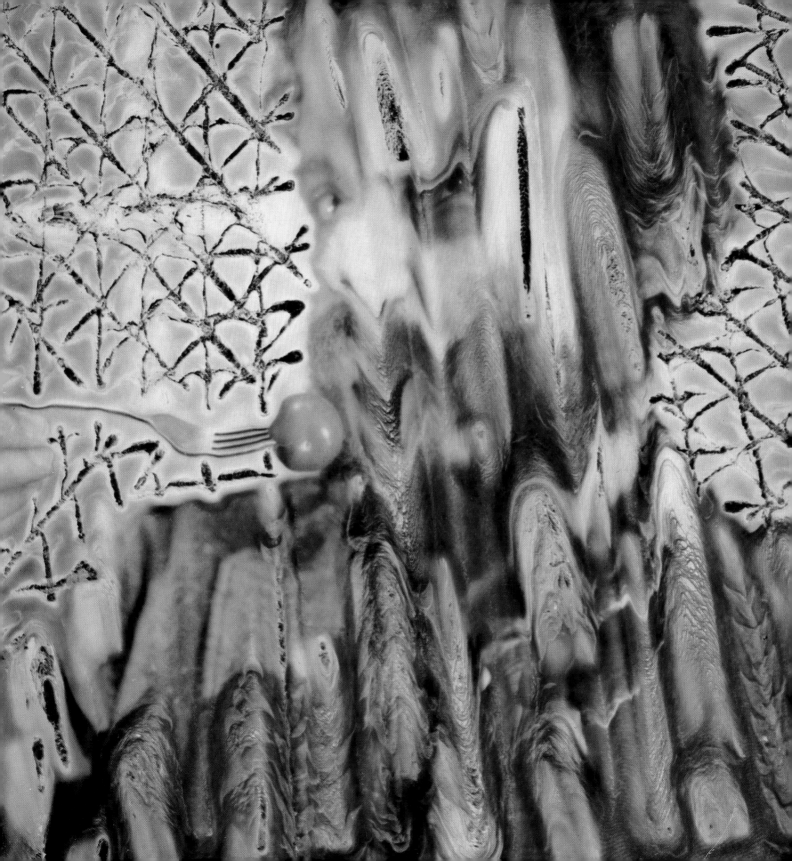

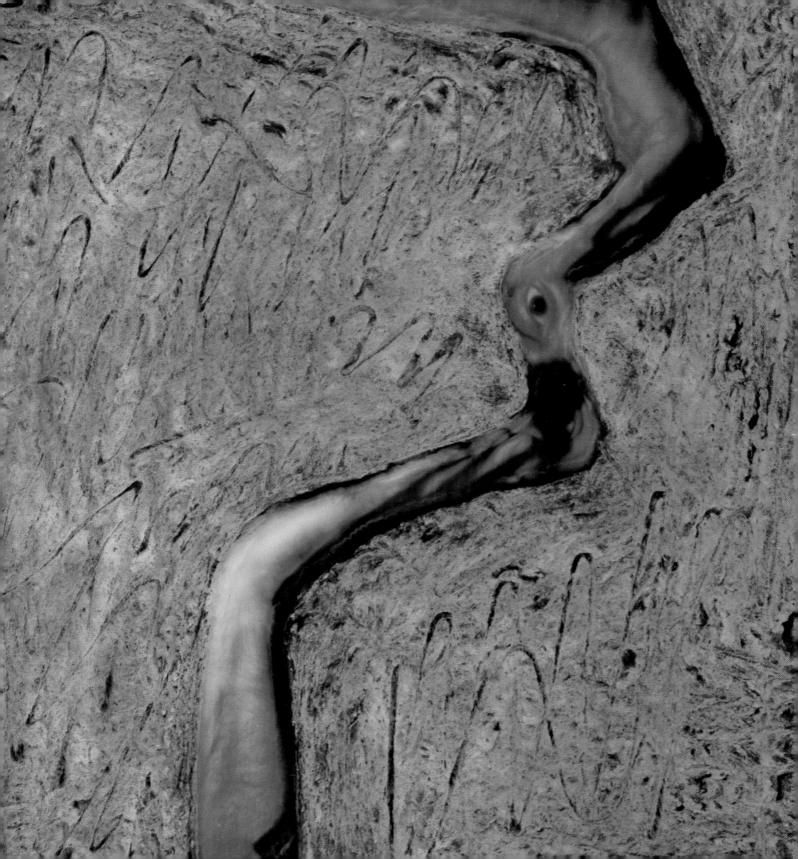

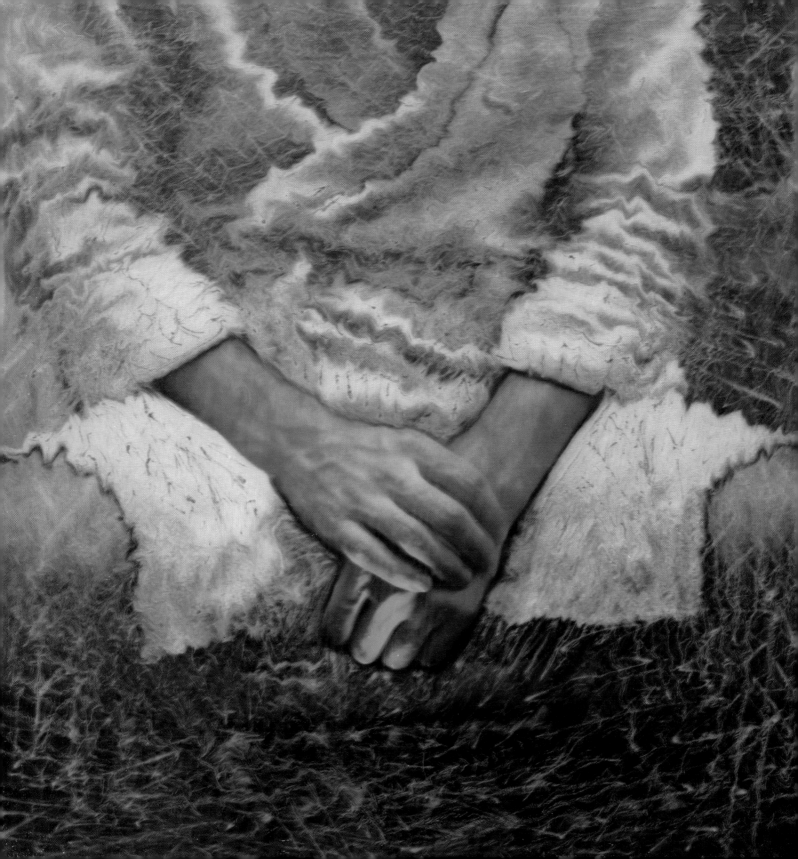

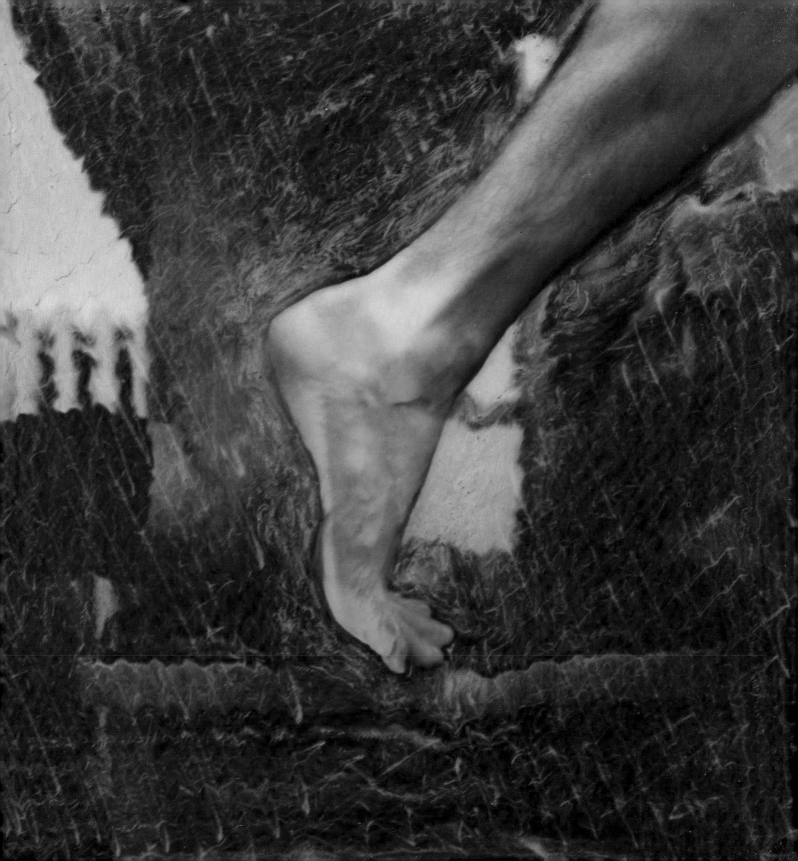

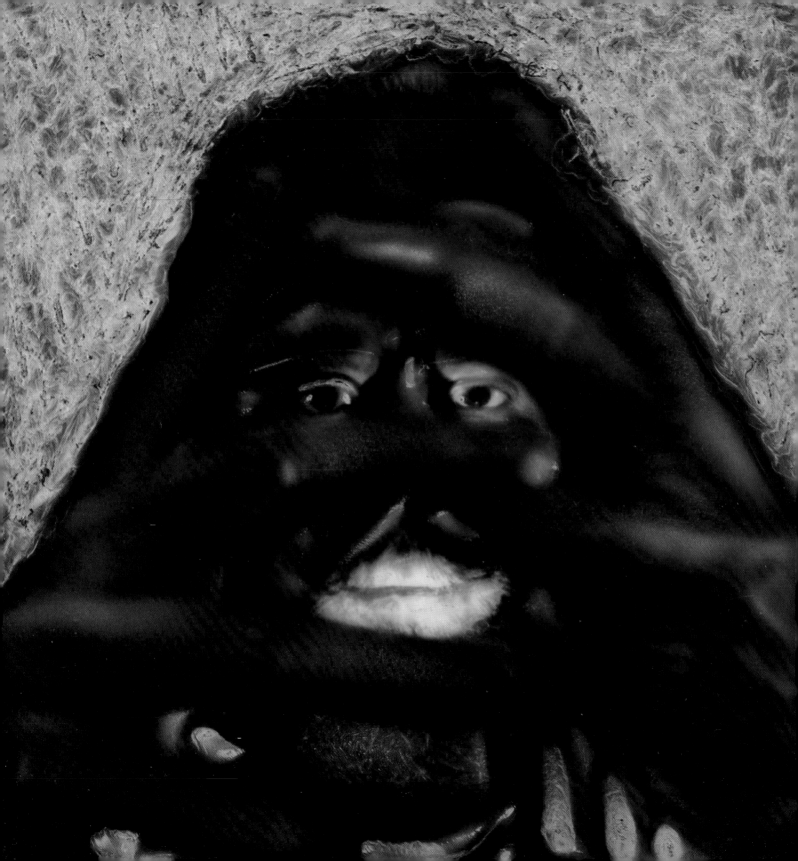

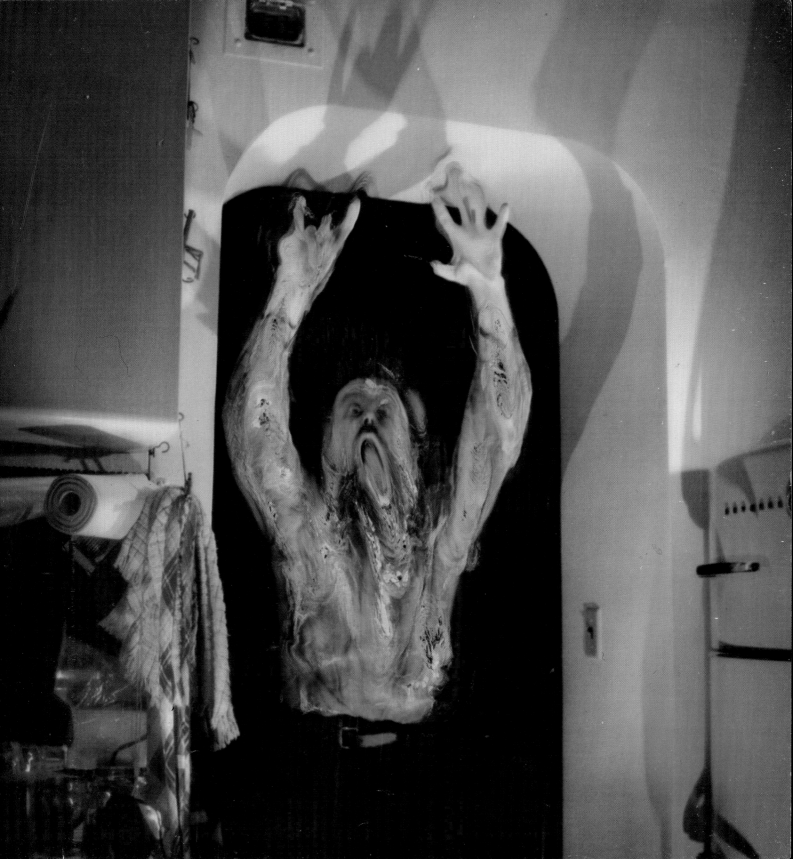

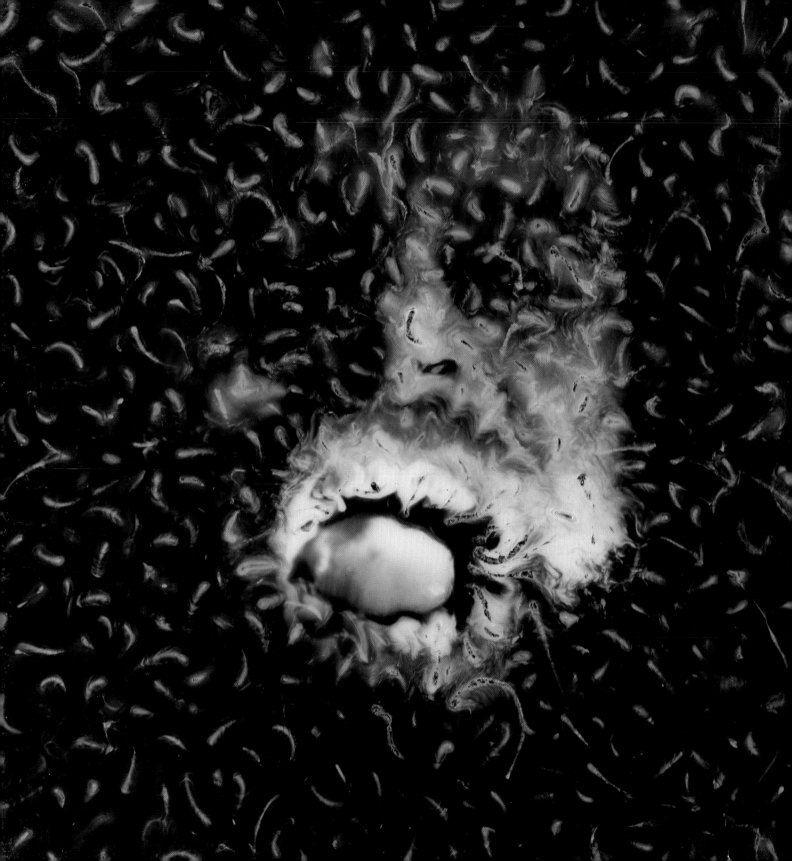

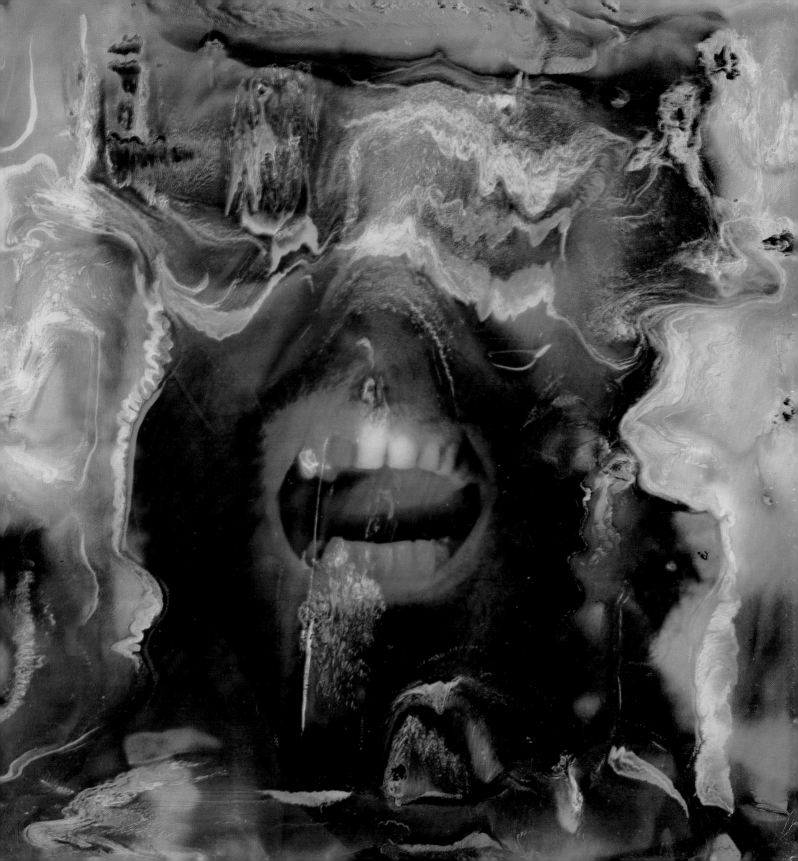

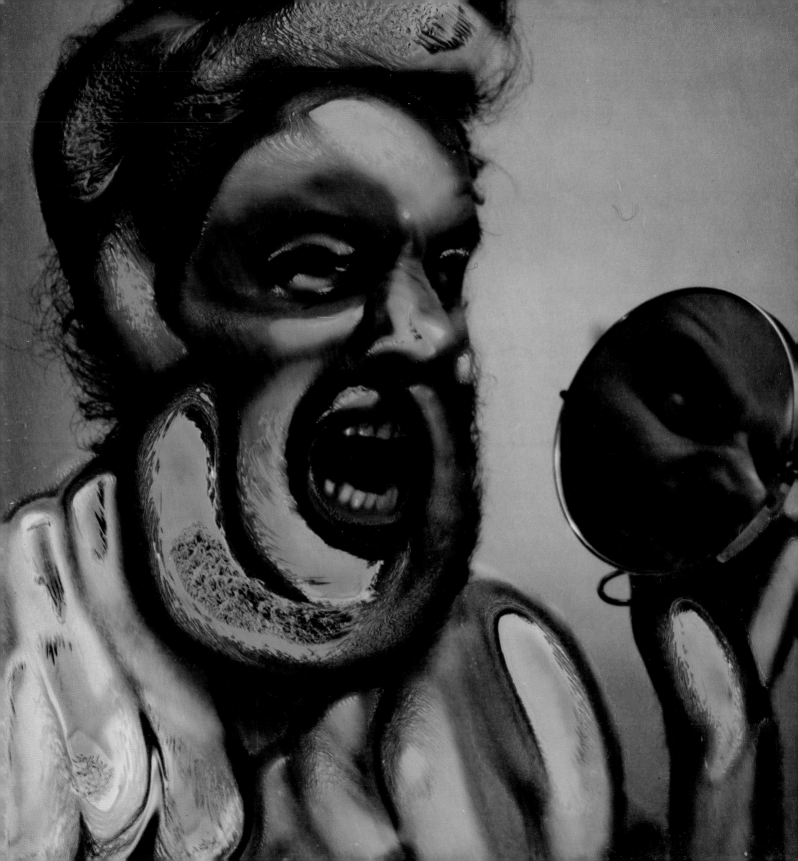

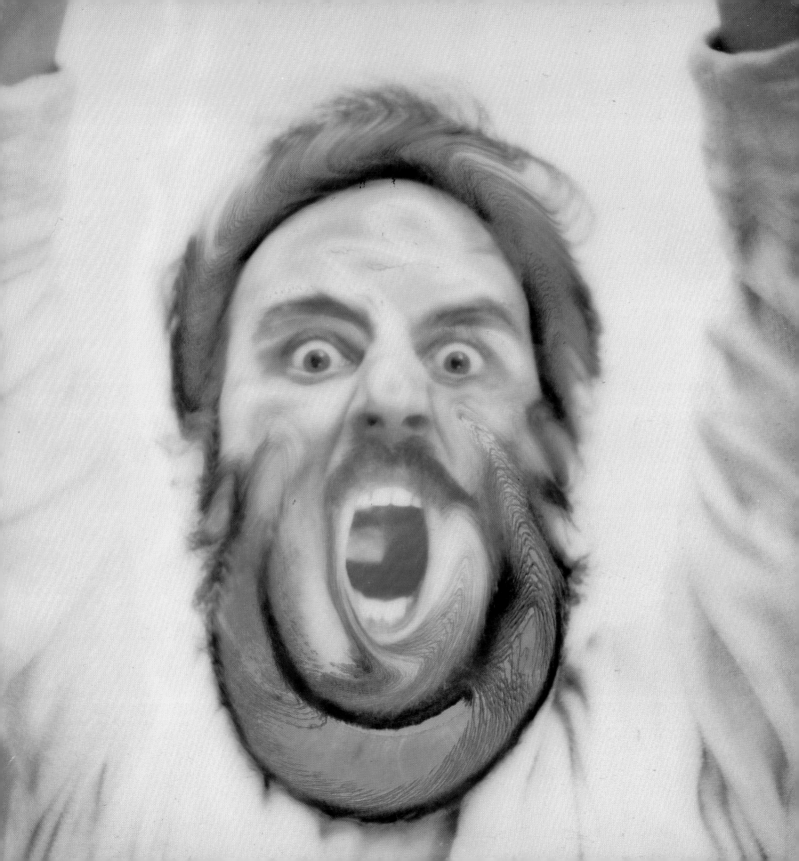

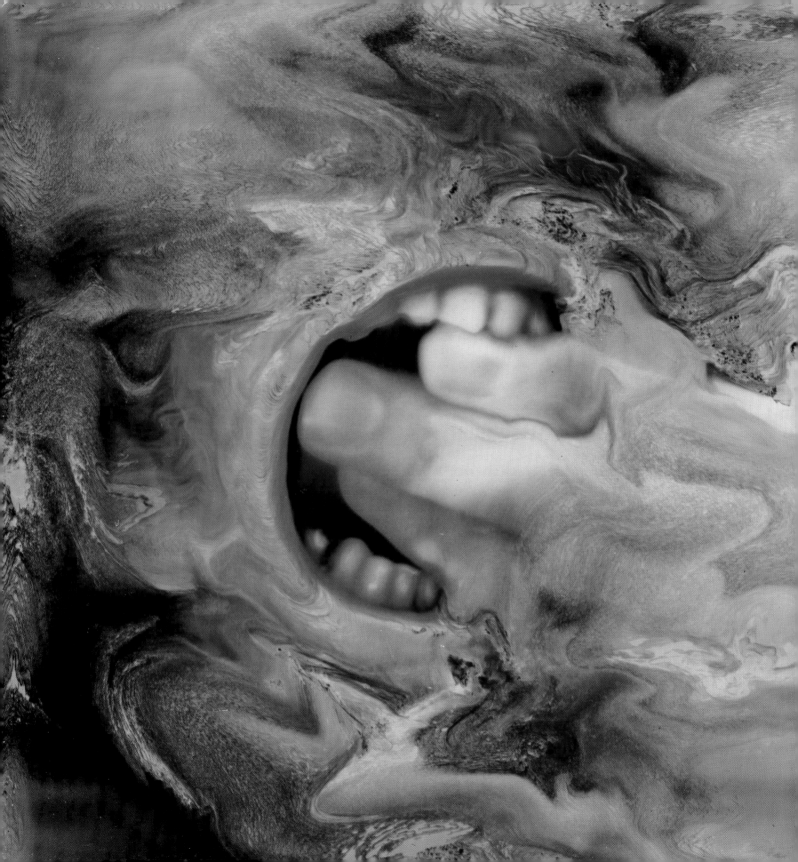

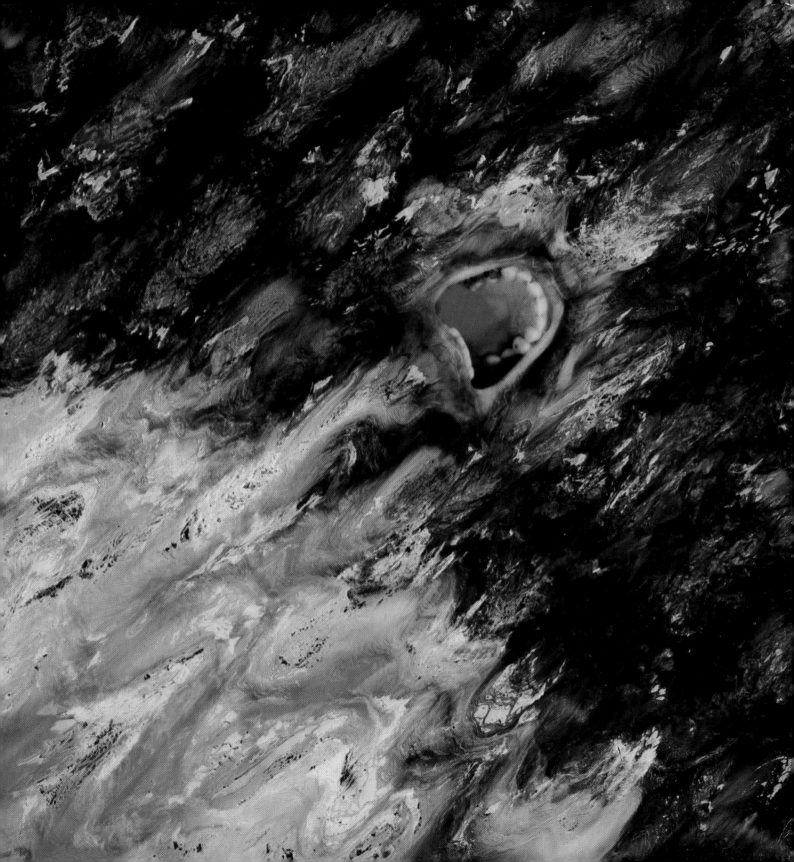

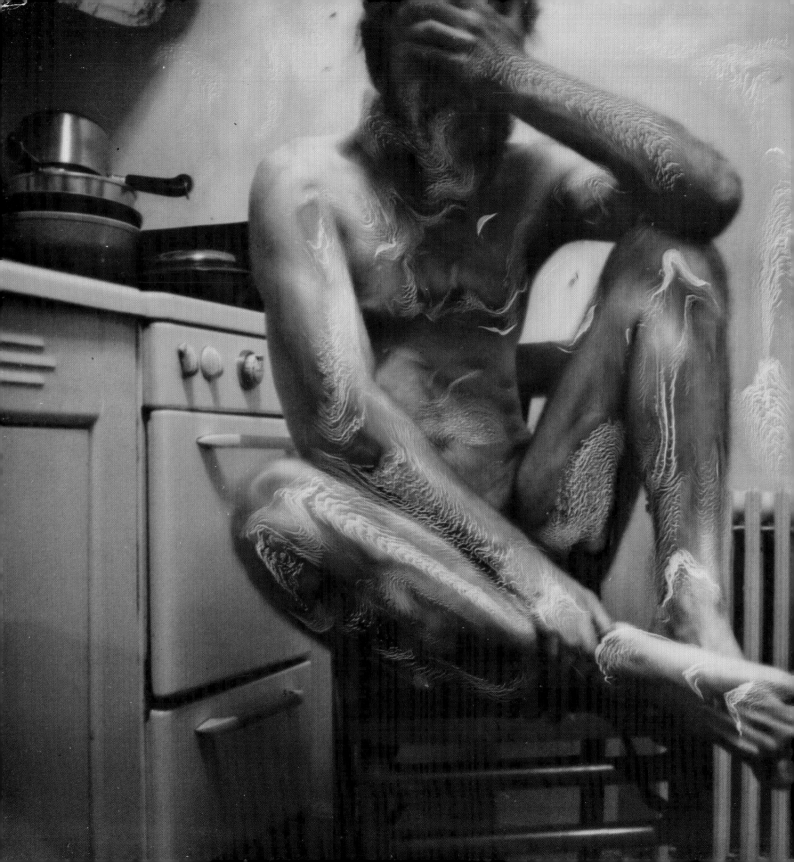

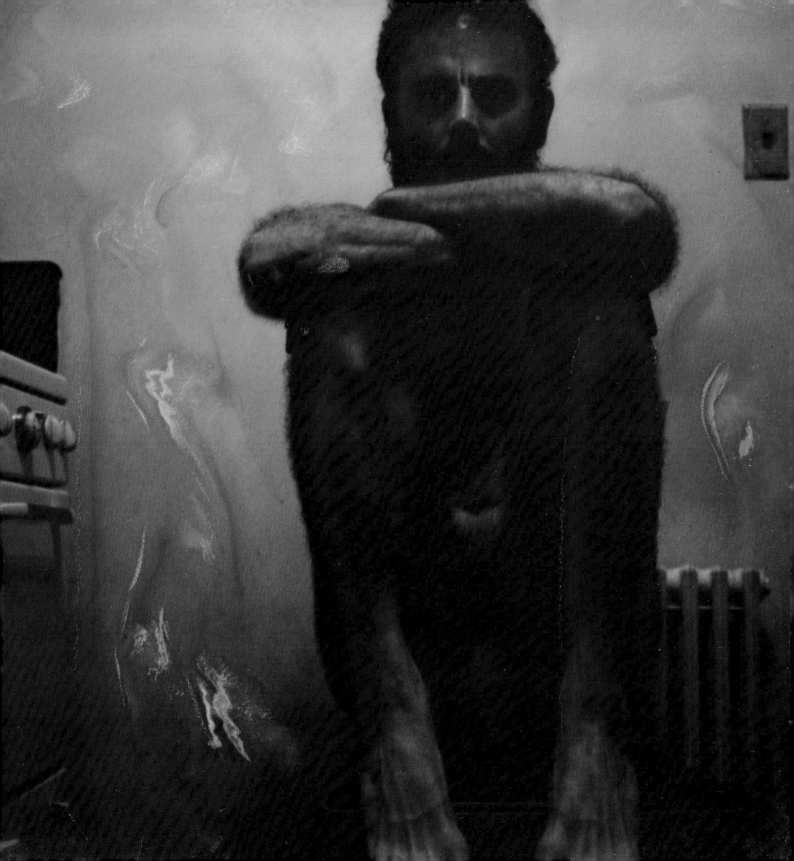

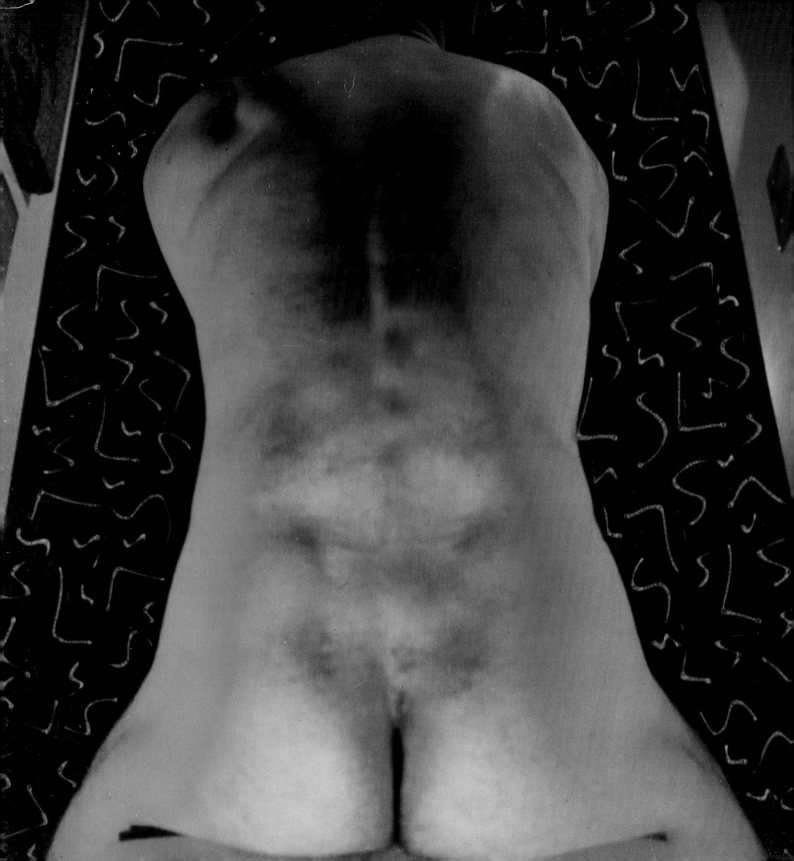

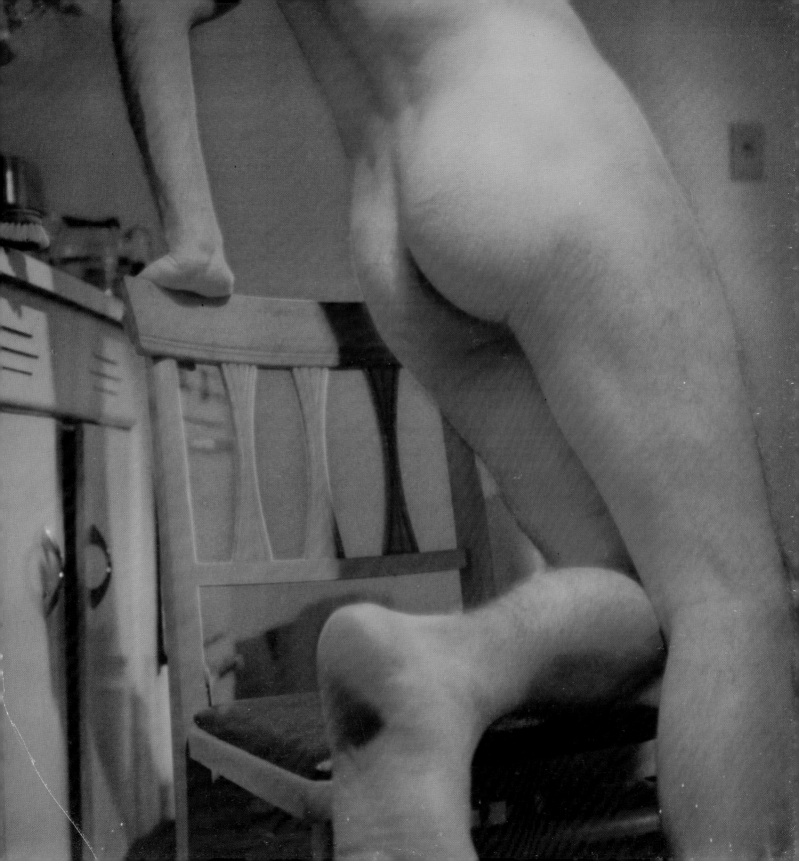

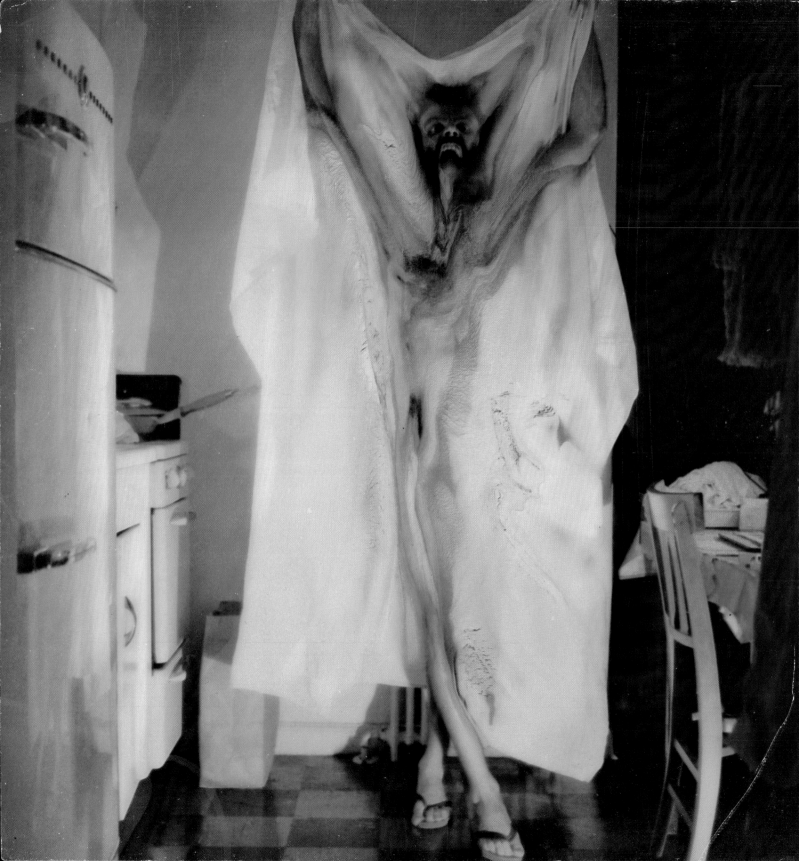

SELECTED CHRONOLOGY

The PHOTO-TRANSFORMATIONS combine an autobiographical continuum, a kind of Theater of the Absurd, and a pervasive concern for transformation (not the familiar transformation of objects but of his own image). This chronology seeks to establish a frame of reference for the convergence, in photography, of these three aspects of Samaras' art. For a complete chronology the author recommends LUCAS SAMARAS by Kim Levin, Harry N. Abrams, Inc., New York, 1975.

1936 Born: Kastoria, Macedonia, Greece.

1948 Arrives in the United States. Lives in West New York, New Jersey.

1955-59 Attends Rutgers University and meets artists Allan Kaprow, George Segal and Robert Whitman, with whom he will participate in the earliest Happenings. Acts in university theater.

1959 Acts in Happenings at Ruben Gallery with Claes Oldenburg, Jim Dine and Red Grooms. Has first one-man show of oils and pastels at Ruben November 6-26.

1960 Attends Stella Adler Studio Theater. Begins BOXES. First use of mirror. Faces appear, molded in plaster.

1961 Begins DINNER series. DINNER #0 undergoes a number of transformations between 1961-63. The photo self-portrait under the foot of the glass was probably added in 1963.

1962 Acts in Claes Oldenburg's and Robert Breer's film "Pat's Birthday."

1963 Acts in Ray Saroff's film, "The Real Thing." Begins using photographs of himself in BOXES and DINNERS. Self-portraits, secreted or exposed, appear in most BOXES from this date.

1964 Moves to New York City.

1965 Makes pin drawings on sheets of x-ray film. Though not yet titled TRANSFORMATIONS, he begins changing and manipulating everyday objects such as a tennis racket, shoes, and a chair.

1966 Continues x-ray drawings, culminating in an untitled work composed of pins, a photograph and an x-ray of the artist's skull. Uses a double nude photograph in LARGE TINFOIL FINGERS (destroyed). Makes first work using the word transformation in the title — TRANSFORMATION (EYEGLASSES).

1967-68 Moves to New York's Upper West Side. Continues mirror structures begun in 1966. Begins paper silhouette drawings. Continues TRANSFORMATIONS.

1969 Writes, directs and acts in film SELF, photographed and edited by Kim Levin. Film premiers at the Museum of Modern Art in August. He is photographed by his friend Martha Edelheit (with a Polaroid camera). Photo accompanies an article by Kim Levin ("Samaras Bound," ART NEWS. February 1969). December 1969 purchases Polaroid camera. Begins series of AUTOPOLAROIDS which exceed 405 at the time of the publication of the SAMARAS ALBUM in 1971.

1970 Writes about the "Autopolaroids," ART IN AMERICA. (November-December 1970).

1971 The SAMARAS ALBUM is published and all 405 AUTOPOLAROIDS are exhibited at the Pace Gallery in October.

1972 The AUTOPOLAROIDS comprise a section of Samaras' retrospective exhibition at the Whitney Museum of American Art, November 18, 1971-January 7, 1973. Other AUTOPOLAROID exhibitions include Harcus-Krakow Gallery, Boston; Moore College of Art, Philadelphia; and Documenta V, Kassel, Germany.

1973 At the suggestion of Harold Jones, Director of Light Gallery, John Holmes with Polaroid, calls on Samaras and gives him the new SX-70 camera. The first photograph, of Holmes, is dated 9/73. First experimental results of the use of the SX-70 are shown at Light Gallery in an exhibition titled BY SX-70, November 6 - December 1, 1973. Works by Carl Chiarenza, Mark Cohen, Chrisian Delbert, Charles Eames, Emmet Gowin, Art Kane, Eugene Richards, William Wray and others are also included. Begins series of PHOTO-TRANSFORMATIONS in Sept. 1973 which will occupy him until June 22, 1974.

1974 Makes no photographs from 6/22/74 to 7/75. PHOTO-TRANSFORMATIONS are exhibited at the Pace Gallery, March 23 - April 27, and in the 71ST AMERICAN EXHIBITION, Chicago Art Institute. In addition three are included in PHOTOGRAPHY IN AMERICA, The Whitney Museum of American Art, November 20, 1974 - January 12, 1975.

1975 PHOTO-TRANSFORMATIONS are included in BODYWORKS, Museum of Contemporary Art, Chicago; RICHARD BROWN BAKER COLLECTS, Yale University Art Gallery, New Haven; and exhibited at the Makler Gallery, Philadelphia. Begins new series in July. Exhibition of new works, including second PHOTO-TRANSFORMATION series from 7/75 is held at the Pace Gallery October 25 - November 22.

SELECTED BIBLIOGRAPHY

References are arranged chronologically and are specifically related to Samaras' photography, beginning with the film SELF in 1969. For complete bibliographic references related to Samaras' entire body of work LUCAS SAMARAS edited by Robert Doty, Whitney Museum of American Art, New York, November 1972 - January 1973; and LUCAS SAMARAS by Kim Levin, Harry N. Abrams, Inc., New York, 1975 are recommended.

1969 Glueck, Grace. "A Little Fetish Footage," THE NEW YORK TIMES. (August 3, 1969).

Schjeldahl, Peter. "Exhibition at the Museum of Modern Art," ART INTERNATIONAL. (October 1969).

1970 Samaras, Lucas. "Autopolaroids," ART IN AMERICA. (November - December 1970), pp. 66 - 83.

1971 Campbell, Lawrence. "Reviews and Previews," ART NEWS. (December 1971), p. 19.

Glynn, Eugene. "Books in Review," (SAMARAS ALBUM), THE PRINT COLLECTOR'S NEWSLETTER. (November - December 1971), pp. 106-107.

Gruen, John. "Galleries and Museums: The Best Thing in Life is Me," NEW YORK. (October 18, 1971), p. 80.

Kurtz, Bruce. "Samaras Autopolaroids," ARTS MAGAZINE. (December 1971 - January 1972).

Kramer, Hilton. "Noland Paintings Begin a New Series," (reviews), THE NEW YORK TIMES. (October 23, 1971).

Ratcliff, Carter. "New York Letter," ART INTERNATIONAL. (January 20, 1971), p. 32, 84.

Samaras, Lucas. SAMARAS ALBUM. The Whitney Museum and Pace Editions, New York. 1971.

1972 Baker, K. "Reviews," ARTFORUM. (May 1972), pp. 86-89.

Belz, Carl. "At H-Krakow-II: The Artist's Image as Object," BOSTON AFTER DARK. (February 1, 1972).

Bernstein, Richard. "Interview," ANDY WARHOL'S INTERVIEW. (December 1972).

Bunnell, Peter. PHOTOGRAPHIC PORTRAITS. Moore College of Art, Philadelphia. 1972.

"Going the Way of All Flash," THE VILLAGE VOICE. (November 30, 1972).

Hughes, Robert. "Menaced Skin," TIME MAGAZINE. (November 27, 1972).

Kramer, Hilton. "Inspired Transformations," THE NEW YORK TIMES. (November 26, 1972).

Levin, Kim. "Eros, Samaras and Recent Art," ARTS MAGAZINE. (December 1972 - January 1973).

Palazzolo, Carl. "At H-Krakow-I Samaras: Autopolaroids Primarily," BOSTON AFTER DARK. (February 1, 1972).

Samaras, Lucas. LUCAS SAMARAS. (Robert Doty, ed.), Whitney Museum of American Art, New York. (November 1972 - January 1973).

"The Other Tradition," NEW YORK. (December 11, 1972).

1973 Hunter, Sam and Jacobs, John. AMERICAN ART OF THE TWENTIETH CENTURY. Harry N. Abrams, Inc., New York. 1973. pp. 295, 331, 490.

Kozloff, Max. "The Uncanny Portrait: Sander, Arbus, Samaras," ARTFORUM. (June 1973).

Samaras, Lucas. "Apropos du Film 'Self'," OPUS INTERNATIONAL. (April 1973).

1974 Baker, Kenneth. "Reviews," ART IN AMERICA. (July - August 1974).

Doty, Robert. (ed.). PHOTOGRAPHY IN AMERICA. The Whitney Museum of American Art, Random House, Inc. and The Ridge Press, Inc., New York. 1974.

Glimcher, Arnold. LUCAS SAMARAS PHOTO-TRANSFORMATIONS. The Pace Gallery, New York. (March 23 - April 27, 1974).

Glynn, Eugene. "Reviews," ART NEWS. (June 1974).

Greenfield, Lois. "Lucas Samaras: Transfigured, Mutilated, Fragmented, and Abstracted . . .," CHANGES. (June 1974).

Kozloff, Max. "Reviews," ARTFORUM. (June 1974).

Kramer, Hilton. "A Fresh Look, in Photos," THE NEW YORK TIMES. (March 30, 1974).

Van Baron, Judith. "Reviews," ARTS MAGAZINE. (March 1974), p. 53.

1975 Beaton, Cecil and Buckland, Gail. THE MAGIC IMAGE. Little, Brown and Co., Boston and Toronto. 1975. p. 251.

Levin, Kim. LUCAS SAMARAS. Harry N. Abrams, Inc., New York. 1975.

Licht, Ira. BODYWORKS. Museum of Contemporary Art, Chicago. 1975.

Savitt, Mark. "Shamanistic Aspects of Some Recent Art," RICHARD BROWN BAKER COLLECTS. Yale University Art Gallery, New Haven. 1975.